HOUSE GUESTS: THE GRANGE 1817 TO TODAY

essays by Charlotte Gray, Jennifer Rieger and Jessica Bradley

edited by Jessica Bradley and Gillian MacKay

HOUSE GUESTS

THE GRANGE 1817 TO TODAY

Art Gallery of Ontario, Toronto

Printed in Canada

The Art Gallery of Ontario is funded by the Ontario Ministry of Citizenship, Culture and Recreation. Additional operating support is received from the Volunteers of the Art Gallery of Ontario, City of Toronto, the Department of Canadian Heritage, and The Canada Council for the Arts. Contemporary programming at the Art Gallery of Ontario is supported by The Canada Council for the Arts through the Assistance to Art Museums and Public Galleries program.

"The Draped Mirrors" p. 100, is reprinted from DREAMTIGERS by Jorge Luis Borges, translated by Mildred Boyer and Harold Morland, copyright ©1964, renewed 1992. By permission of the University of Texas Press.

National Library of Canada Cataloguing in Publication Data

Main entry under title:

House guests : the Grange 1817 to today

Published on the occasion of the Art Gallery of Ontario's centenary, and to accompany the exhibition House guests: contemporary artists in the Grange, Sept. 15, 2001 – Jan. 27, 2002.

1. Art, Canadian–20th century–Exhibitions. 2. Art, American–20th century–Exhibitions. 3. Grange, The (Toronto, Ont.)–History. I. Gray, Charlotte, 1948– II. Rieger, Jennifer A. (Jennifer Anne), 1952– III. Bradley, Jessica IV. MacKay, Gillian

V. Art Gallery of Ontario.

N910.T6H68 2001 709'.71'074713541 C2001-903222-6

ISBN 1-894243-19-6

CONTENTS

FOREWORD

For those who care to look, Toronto is surprisingly rich in survivals of sites and buildings evocative of its 200-year evolution from colonial outpost to modern city.

How many have visited, or are even aware of, for example: Fort York, birthplace of Toronto (then York) in 1793; the Garrison Cemetery (1793–1863) at Portland and Wellington Streets, containing some 400 burials (including an infant daughter of Lieutenant Governor Simcoe) and one of sculptor Walter Allward's earliest commissions; or the Central Block of the 1844 City Hall, now home to the city's Market Gallery? These represent but a tiny fraction of our still-visible heritage.

As in the natural world, their survival is the result of successful adaptation. For buildings this usually means an ability to accommodate the new uses demanded by the changing needs of the growing city.

The Grange is as significant a survivor as any. The oldest remaining brick house in Toronto, it has evolved from Georgian home, through art gallery to historic house museum, and its adaptations have been more successful than most. Over the years the building has retained its physical integrity, thanks both to an enlightened trusteeship and a fervent band of dedicated volunteers.

Today The Grange is in the midst of its most recent transformation. The Grange Council, the house's advisory body, after a reassessment of the institution's strategic direction, determined that the future health and effectiveness of The Grange would best be assured by seeking to strengthen its historic links with its parent body, the Art Gallery of Ontario.

While it continues to operate as a historic house with costumed interpreters, a new emphasis is being placed on reintegrating The Grange into the programming and exhibition activities of the AGO, as part of the Canadian Department.

The exhibition *House Guests: Contemporary Artists in The Grange* symbolizes, in a most dramatic and satisfying way, the opportunities for a new life for The Grange in promoting an understanding and appreciation of art in Toronto and Ontario.

The Grange Council is excited to be helping the AGO celebrate its first one hundred years through supporting this publication and welcoming the exhibition *House Guests: Contemporary Artists in The Grange.*

R. Scott James
CHAIR, THE GRANGE COUNCIL

PREFACE

One hundred years ago The Grange was a meeting place, a gracious and hospitable home at the centre of Toronto's social, cultural and political life. In bequeathing The Grange to the Art Museum of Toronto, in the desire that it would serve as the city's first art museum, Harriette Boulton Smith and Goldwin Smith could hardly have foreseen the scale and richness of the Art Gallery of Ontario as we now know it today. At the dawn of our second century, The Grange symbolizes in so many ways our grandest ambitions to bring people together to discover, experience and celebrate works of art.

Living artists were active architects in planning The Grange's future as an art museum. Indeed contemporary artists presented their works within its walls in the first public exhibitions held there. Both the book *House Guests: The Grange 1817 to Today* and the exhibition it accompanies, *House Guests: Contemporary Artists in The Grange*, acknowledge the crucial role contemporary artists play in creating a living culture. Artists open new paths of discovery, pleasure and inquiry.

As custodians of our visual culture, art museums are dedicated not only to preserving the past but also to anticipating our future. Museums strive to ensure that the artistic production of our time is recognized and made available to us in compelling ways, and that it is preserved for our children.

Enlightened collectors, donors and sponsors add immeasurably to an institution's role in linking contemporary artists and their public. Carol and David Appel, and Jerry and Joan Lozinski, who have sponsored *House Guests*, are exemplary patrons. We laud their vision and thank them for their wholehearted support in this as in other endeavours of the Art Gallery of Ontario. With the Lozinskis and the Appels, we salute the artists for their courage and creativity. Their openness to the history of The Grange, and to the ideas generated by its real and layered space, offer varied and rewarding ways of bringing the past to life. We are all in their debt.

The Grange was restored from 1969 to 1973 with the passionate support of members of the Women's Committee. Today both the house and its visitors continue to be cherished and attended to by committed volunteers under the leadership of The Grange's curatorial assistant Jennifer Rieger and Avril Stringer, chair of The Grange Volunteer Committee.

This beautiful book has come into being with the generous support of The Grange Council and its chair Scott James who, with chief curator Dennis Reid,

has led The Grange to this felicitous moment of celebration and recognition. Renowned author and social historian Charlotte Gray has brought the early days of The Grange and the city of Toronto to life in her informative and engaging essay. Jennifer Rieger has illuminated the more recent reincarnations of The Grange as a historic house museum, and Jessica Bradley has shared her understanding of the artists' projects and the meaning of their interventions in this historic site. In parallel, arts writer Gillian MacKay has further distilled the artists' visions in edited statements by and conversations with them, and with Jessica Bradley she has ably edited the entire publication.

The results are illuminating and memorable. I can think of no better testament to the ambitions of the Art Gallery of Ontario in this special year. *House Guests* is a fine balance between the celebration of our past and our commitment to the present.

Matthew Teitelbaum
DIRECTOR, ART GALLERY OF ONTARIO

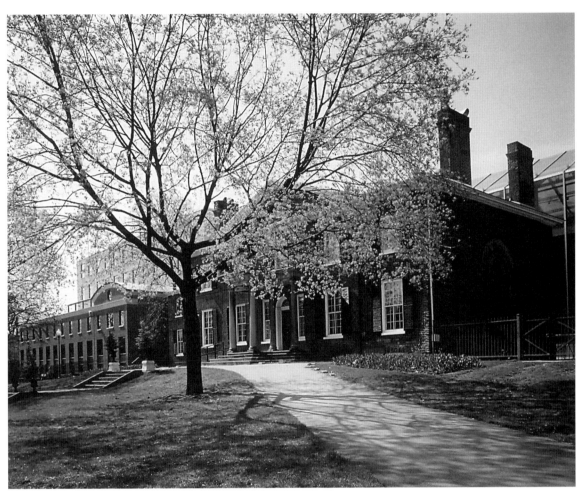

1. View of The Grange from Grange Park, 1999.

ACKNOWLEDGEMENTS

House Guests: Contemporary Artists in The Grange had been in the collective curatorial imagination for some time. The dream of inviting contemporary artists to respond to the Art Gallery of Ontario's historical home came true as we approached our centennial year. My former colleague, Christina Ritchie and I began to draw up lists of artists we felt might flourish in this context. A book about The Grange that encompassed the house's recent links with the history of the Art Gallery of Ontario, as well as the roots of this history in the early life of the city of Toronto, became part of the exhibition project. Several individuals were instrumental in realizing this vision.

The enthusiasm of Matthew Teitelbaum, director, and Dennis Reid, chief curator, guided our course. Jennifer Rieger, curatorial assistant responsible for The Grange, rekindled the idea of contemporary interventions in this historic house with her invitation to make a proposal. She was tireless in her commitment to the project, engaging the volunteers who work in The Grange and her colleague Douglas Worts, curatorial educator in the Canadian Department. Avril Stringer, chair of The Grange Volunteer Committee, was a watchful and dedicated representative of the volunteers throughout the planning process, and Scott James, chair of The Grange Council, lent his expertise and encouragement to support this publication.

Linda Milrod, director of Exhibitions and Publications, led the development of this multi-faceted centennial publication from conception to production and Jill Cuthbertson, project manager in the Exhibitions and Publications department, oversaw all stages of the exhibition preparation, building generous and supportive relations with the artists along the way. In the Contemporary Department, Maureen Boles, administrative assistant, kept track of countless details and provided tirelessly good-humoured support. In the Education Department, Janna Graham of the Teens Behind the Scenes program devised *Sounds of The Grange*, working with participant artist and youth mentor Luis Jacob to bring this innovative electronic creation to fruition. Doris Van Den Brekel, program coordinator of Volunteer Training, organized docent training and Gillian McIntyre, coordinator of Adult Programs, oversaw the artists' talks and the panel discussion "Intervention and the Historic House". Our colleagues in Development, especially Leslie Belzak, provided gracious support and opening celebrations. Aleksandra Grzywaczewska produced innovative and sensitive design components and Carrie Shibinsky ably coordinated

press relations. The demands on the AGO's incomparable technical services staff were detailed and often unpredictable. Their efforts contributed greatly to the success of the installation.

This publication marks a special moment of celebration and collaboration in the meeting of historical essay, curatorial text, artists' statements and exhibition catalogue. Nigel Smith and Tearney McMurtry of Hahn Smith Design have conceived the elegant and lucid design of this publication with sensitivity, to make a beautiful and accessible keepsake book. Laura Brown, curatorial assistant to the chief curator, lent her incomparable production editing skills to this publication as it went to press, as did freelance copy editor Noni Regan. Steven Evans made extraordinary photographs of the interior of The Grange under challenging circumstances and with sympathetic understanding of the artists' works.

An exhibition such as *House Guests* entails many special considerations and pleasures. I thank Christina Ritchie for our early conversations and collaboration in conceiving the exhibition, along with the many colleagues who endorsed the idea enthusiastically. Charlotte Gray's agreement to write an essay for this book was as inspiring as her eventual text. She was a delight to work with, as was Gillian MacKay who edited the publication and warmly embraced the formidable task of plumbing the depths of the artists' thoughts about their projects with sensitivity and with the curiosity of the dedicated art lover.

Curators of contemporary art are blessed with the responsibility of working closely with artists and making every effort to assure their vision is well represented. Much of what we do is necessarily based in faith, especially in a project such as *House Guests* where the works would only exist weeks before the exhibition opened. Rebecca Belmore, Robert Fones, Luis Jacob, Elizabeth LeMoine, Josiah McElheny, Elaine Reichek, and Christy Thompson rose to the occasion with admirable dedication and insight. Without the advantage of considering their work in the studio before presenting it, they have shared their creative responses to The Grange with us. For this, their good humour, friendship and trust, I thank them and on their behalf as well as my own, I thank Jenny Rieger for the pleasure of working with her and discovering a new collegial relationship. The support of sponsors Carol and David Appel, and Jerry and Joan Lozinski has meant more to us all than balancing the budget. Finally,

the interest and dedication of the Contemporary Curatorial Committee at the Art Gallery of Ontario is an encouragement to my work as lead curator in the Contemporary Department and to the contemporary programs that vitalize a great museum.

Jessica Bradley
CURATOR OF CONTEMPORARY ART
ART GALLERY OF ONTARIO

AT HOME
IN THE GRANGE

Charlotte Gray

Part I: Mrs. Sarah Anne Robinson Boulton 1817–1846

When Sarah Anne Boulton first stood before the dignified wooden portico of her new home, she could not fail to be impressed. It was months since the builders first broke ground in 1817, and it would be longer still before vegetable and flowerbeds replaced the ugly stumps in the clearing round the house. Nevertheless, the mansion was all that she hoped for. Its red-brick bulk surpassed any of its near neighbours in the New World, whilst its classical symmetry rivalled the best houses in the Old World. It could only reflect well on its new mistress: a slender woman with penetrating blue eyes, now nearing her thirtieth birthday.

Ten years earlier, Sarah Anne's husband D'Arcy Boulton had paid 350 pounds for 100 thickly forested acres in the tiny settlement of York. Now he named his new home, sited amongst the towering trees, The Grange, after the Boulton family home in Lincolnshire. Sarah Anne had never seen the original Boulton Grange, since she had been born in Lower Canada in 1789. And it is doubtful her husband had strong memories of the ancestral property, since his own family had never lived there. D'Arcy was only 12 when he, with his parents and brother, crossed the Atlantic in 1797. But like many of the leading families in Upper Canada, the Boultons clung to British standards and values. They wanted to replicate in the raw young colony the way of life their forefathers had enjoyed back home. They were already working hard to do so, by implementing a British legal system and dabbling in commerce and land speculation. D'Arcy Boulton had proved his loyalty to the Crown when he, along with others in the colonial militia, was detained by the

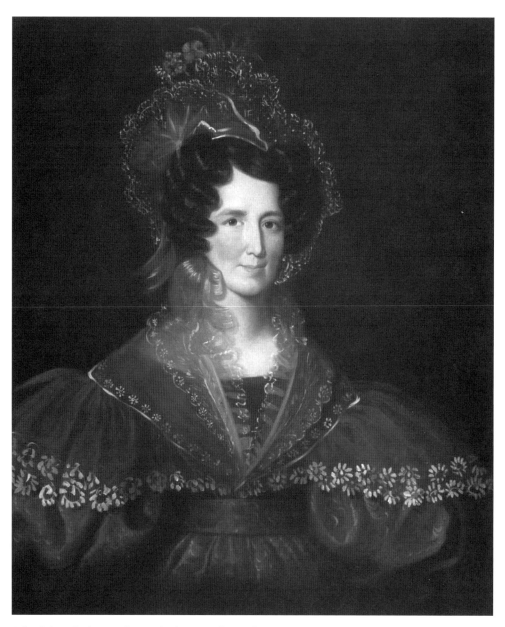

2. Sarah Anne Boulton was "a very pleasing woman", according to an acquaintance.
She was also a woman of impeccable style, as this c.1830 portrait by James Bowman reflects.
AGO, bequest of Mabel Cartwright, 1955.

Yankees in 1813, after the Americans had captured York, the colony's capital, and burned down the parliament buildings there. Now he was a qualified lawyer and a well-known merchant in York. His father D'Arcy Senior was a judge, and his younger brother Henry John Boulton, aged only 28, was the solicitor general of Upper Canada.

Sarah Anne's own family was of Loyalist stock. Raised in a tradition of unswerving devotion to the mother country, the Robinsons began life in the New World as prosperous landowners in eighteenth century Virginia. When the American colonies revolted against the British crown, Sarah Anne's father chose to turn his back on his estates and travel north. Like the Boultons, the Robinsons cherished a sense of civic duty and position. Sarah Anne's older brother, the businessman Peter Robinson, had been in partnership with D'Arcy Boulton for a time. Her younger brother, John Beverley Robinson, was attorney general and destined to become one of the young colony's leading power brokers.

Maybe York was still only a muddy little settlement squeezed between Lake Ontario and the vast unexplored forests that stretched endlessly north. Maybe the *soi-disant* capital consisted in 1820 of only about 180 buildings, most of which were squalid wooden one-storey shacks. Maybe the 1,240 residents of the backwoods outpost were more fearful of bears in their backyards than of committing a *faux pas*. Perhaps an English visitor was right when he sneered that York was "better calculated for a frogpond or a beaver meadow than for a residence of human beings." But York's elite, which numbered fewer than a hundred people, took themselves and their ambitions seriously. Its members insisted that standards must be set and rank recognized. The Boultons and the Robinsons, along with the Powells, the Macaulays, the Jarvises, and the Baldwins, had no interest in the Yankee values and popular democracy that characterized towns south of the border. Many of the men in these families had once sat in the same schoolroom, taught by the redoubtable Reverend John Strachan. Strachan, an ambitious Scottish schoolmaster who himself came from humble origins, instilled in his students British patriotism, devotion to the Anglican Church, and an unshakeable confidence in themselves. As Mrs. William Dummer Powell, the waspish wife of the chief justice, noted in a letter to her brother, unless "our

society" remembered to "pay and receive civilities [and] proper respect", they risked becoming little better than "Savages."

The Grange, Sarah Anne knew, would be the perfect backdrop for the gossipy little world of "our society", which met regularly for musical evenings, whist parties and subscription balls. It was one of only a handful of houses built in brick, the clay for which came from the Don Valley. As guests walked up the four wide shallow steps to the doorway, with its delicate fanlight, they would quickly realize that the family inside deserved "proper respect." The Grange exuded an intimidating dignity. Guests had to wait to be admitted since there was no latch on the exterior of the heavy front door. When they finally stepped across the threshold, they were faced with ceilings almost twelve feet high, and a pine floor that gleamed with polish. The drawing room, in which the Boultons might receive callers and serve tea in delicate Staffordshire china cups, was on the right of the hallway. Its black walnut baseboards came from trees cleared to build The Grange. On the left was the dining room, also trimmed in black walnut, where a party of fourteen might comfortably enjoy a supper of salmon, venison, snipe or duck, freshly caught or shot within a mile of the Boultons' kitchen. And if anybody should suggest that the Boultons might be New World *arrivistes*, the Boulton family crest — a bolt from a crossbow piercing a large barrel, or "tun" — was prominently carved on the matching sideboards, on each side of the brick fireplace.

Sarah Anne Boulton had already established a reputation within the York elite as a congenial hostess, whose bright smile and lively conversation put everybody at ease. Her lace collars were always impeccably pressed, her thick brown hair carefully curled, her jaunty bonnets beautifully trimmed. Now she intended to establish The Grange as one of the most prestigious homes in the colony. The Grange, she had decided, would cement the Boultons' pre-eminence within the political and social life of Upper Canada. What Sarah Anne Boulton wanted, she usually got.

However, there would be much more to the Boultons' new house than gracious entertaining. The Grange would be a warm family home, with plenty of bedrooms for Sarah Anne's growing brood. The Boultons'

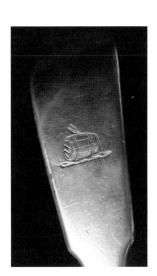

3. The Boulton family crest, depicted on a soup ladle designed by William Stennett c.1832, adorned both silver and sideboards. AGO, gift of Mrs. N. Beverly Heath, 1972.

previous lodgings, over D'Arcy's grocery and dry goods store on King Street a mile to the east, were bursting at the seams with the four sons and one daughter born during Sarah Anne's first ten years of marriage. Another child was already on the way, and by the time Sarah Anne was 40, the nursery would have seen eight little Boultons. But in The Grange, Sarah Anne had room for a reliable English cook, Irish girls to mind her children, and as many maids as she could find or afford. The basement boasted a servants' hall, a wine cellar (D'Arcy was particularly fond of claret), and a kitchen with a large fireplace and brick bake oven. Behind the bull's-eye window in the façade's central gable there were four attic bedrooms for servants.

Equipping a house of this scale was no small challenge. The general stores on King Street stocked only such everyday items as whale oil and candles, tobacco, flour and kitchen earthenware. Most furniture had to be imported from New York, Buffalo or Rochester, or brought up the St. Lawrence from Great Britain via Lower Canada. The nearest cabinet-makers and silversmiths were in Montreal, the largest city in British North America. The catalogue of household necessities for anybody in York with genteel pretensions included mahogany four-post bedsteads; goose-feather covers and pillows; best Whitney blankets (from the town of that name in England); chintz-covered sofas and upholstered chairs; dining, card and Pembroke (or drop-leaf) tables; presses; wardrobes; hearth rugs and a variety of carpeting; complete dinner and tea services; cut-glass decanters, hock glasses, wine rinsers, tumblers, jelly glasses and preserve pots; fire irons and spits; pickling and washing tubs; a mangle (or wringer); castiron pots; plus such luxury items as a reliable mantel clock, an inlaid pianoforte and a commode chair.

Moreover, the Boultons were only one of several families anxious to furnish a splendid residence this year. York was changing. Relations with its American neighbours, although strained, had been patched up after the War of 1812. The uneasy peace had allowed the town to expand its role as both a military and an administrative centre. The end of the Napoleonic conflict in Europe had triggered a wave of immigration into Upper Canada from Britain and Ireland. York's elite prospered as the colonial capital swelled and business thrived. Most of the town's

residents still lived around the original parliament buildings, east of Berkeley Street, but "our society" had started to drift west and build on Front Street facing the waterfront.

Chief Justice Powell had built an imposing house on Front Street that he called Caer Howell after his family seat in Wales. Close by, John Strachan, the colony's intellectual leader, was putting the finishing touches to a brick Regency mansion similar to The Grange, which was quickly dubbed "The Palace." ("Our society" knew that the Reverend Strachan had set his heart on a bishopric.) Sarah Anne's father-in-law, Mr. Justice D'Arcy Boulton Senior, had a large wooden house, painted white and set far back from the road. The D'Arcy Boulton Juniors' new home was so far north of Front Street that Mrs. Dummer Powell scoffed that "Mrs. D'Arcy might as well be in Kingston." But others were even further away. Various members of John Denison's family were building homes within the thick woods west of The Grange. And Dr. William Baldwin, the Irish-born doctor, lawyer, amateur architect and politician, had set himself up as a country squire in Spadina, a new home he had built on his huge estate nearly three miles from the lakefront. Although only rutted cart tracks through the bush linked these dwellings, the outline of a larger, wealthier city was beginning to emerge from this rough, pioneer town.

In their own eyes, the Boultons and their friends constituted the colony's benevolent aristocracy, qualified by breeding and education for public office. They didn't always agree amongst themselves on who should hold which job, or on how issues of land development and road construction should be handled, but they shared an assumption of superiority. Who else in Upper Canada, other than the men who gathered around Sarah Anne's dining table, boasted law degrees and Regency mansions? Who else could be trusted to bind the colony more closely to the glorious mother country?

Moreover, the 1791 Constitutional Act, passed in Great Britain for the government of Upper Canada, almost guaranteed that such a colonial oligarchy would emerge. Control of the colony was concentrated in the hands of two appointed bodies: the Executive Council (an early sort of cabinet) and the Legislative Council (a forerunner of the Senate). Both

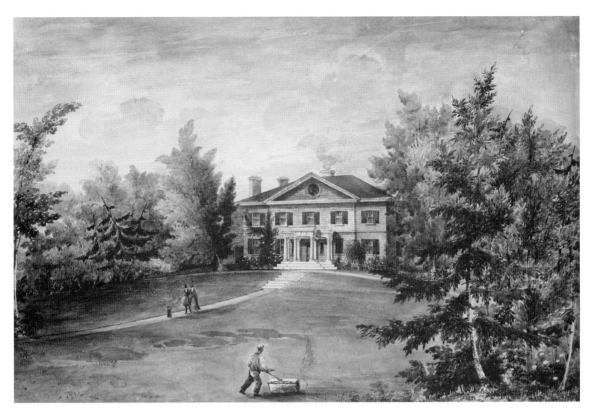

4. A c.1845 watercolour, by Henry Bowyer Lane, indicates that from its earliest days The Grange required an extensive staff both indoors and outdoors. AGO, gift of Mrs. Seawell Emerson, Marblehead, Massachusetts, 1972.

were dominated by Robinsons, Boultons, and the grim-faced Strachan. These were the local insiders to whom a succession of titled British officers, sent out from London to govern the colony, naturally turned for advice. The third tier of government, the elected Legislative Assembly, in which a smattering of craftsmen and backwoodsmen sat alongside minor members of the colonial elite, was virtually powerless: it had no say in appointments, expenditure or policy. And most of its members rarely had the company of men like Sir Peregrine Maitland, governor of Upper Canada between 1818 and 1828, at their dining tables.

Life was as comfortable as Sarah Anne had hoped in The Grange during the 1820s and early 1830s. The surrounding acres were gradually cleared, an orchard was planted and a kitchen garden laid out. Two more daughters and a fifth son were born. York did not offer the choice of milliners and dressmakers for which young women of the period yearned, but the Boulton family took frequent trips by boat so the three girls (Mary, Emma and Sarah) might taste the cosmopolitan delights of Montreal, Quebec and even Saratoga Springs, in upstate New York. And the muddy capital of Upper Canada was a paradise for Sarah Anne's rowdy sons, who had inherited the good looks, sinewy build and stamina of the Boulton side of the family. In winter, Sarah Anne's sons organized skating and ice-boat races on the frozen lake, or went on fox-hunting expeditions with William Jarvis's yapping pack of mismatched hounds. In summer, armed with shotguns, they set out to fill their mother's larder with fowl from the thickets of the Don Valley and the marshy swamplands of the peninsula that curved in an unbroken line around the harbour. Sarah Anne worried constantly that her boys would get involved in the brawls and drunken battles that regularly erupted on the waterfront. The family still hadn't forgotten the occasion in 1817 when D'Arcy's brother, Henry John, was arrested for acting as a second in a duel in which a man was killed.

D'Arcy Boulton Junior was not a particularly gregarious fellow. As his brother-in-law Peter Robinson wrote of him, "Boulton, though excellent-hearted, has his thoughts so completely taken up with his business that he has not time for the common civil offices of friendship." But if D'Arcy was a cold fish who could only talk business, Sarah

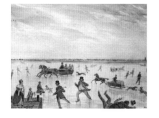

5. Winter activities on Toronto Bay, 1835 depicted in a watercolour by John George Howard.

Anne made up for his deficiencies. A steady procession of smart visitors bounced in their sleek carriages along the rutted track to The Grange's door to pay their respects to her. The Boultons were always on the guest list for such occasions as the celebrated 1827 fancy dress ball, given by John Galt, superintendent of the Canada Company, and Lady Mary Willis, wife of Justice John Willis. Lady Mary appeared as Mary, Queen of Scots; Judge Willis elected to cross-dress and appear as the Countess of Desmond; and Dr. William Baldwin of Spadina swathed a sheet round his muscular torso and strutted around as a Roman senator. (Sadly, nobody recorded what costumes adorned any Boultons.)

In the best tradition of closeknit families, Sarah Anne kept an eye out for her relatives. When D'Arcy's mother died in 1827, old Judge Boulton joined his eldest son in The Grange. When D'Arcy's younger brother William brought a new bride back from England, Sarah Anne took Fanny under her wing. Her brother John teased her that her nerves were bad from "indulgence in strong green tea and from watching and worrying for all your neighbours and kinfolk."

Meanwhile, D'Arcy's fortunes quietly went from strength to strength. In addition to running The Grange estate and the dry goods store, Sarah Anne's husband managed to obtain no fewer than three government jobs. Between 1816 and 1835, he was master-in-chancery (little more than a glorified messenger between the Legislative Council and the House of Assembly) at a salary of 50 pounds a year. He held the unpaid position of magistrate of the Home District Court of Quarter Sessions. In 1828, he added the post of auditor general of Land Patents, with an annual salary of 250 pounds, to his responsibilities. None of these fancy-sounding titles seems to have involved much work, but they gave D'Arcy access to inside knowledge on political and legal issues. This, in turn, put him in a good position to snap up attractive parcels of land, and government contracts for building bridges across the Don and Humber Rivers. By 1825, he had sold his share of the store to concentrate on other interests. He amassed more land close to The Grange's original 100 acres, and he made a killing in 1828 when he sold 51 acres to the north of his house, at 25 pounds an acre, as the site for the new University of King's College.

D'Arcy's close relatives, particularly his brother Henry John and his brother-in-law John Beverley Robinson, achieved far more power and profile in the colony. Both were more ruthless and ambitious than D'Arcy, and probably smarter. Robinson had a finger in every government pie: through the 1820s, he combined the office of attorney general with membership of the Legislative Council and the Legislative Assembly. When he became chief justice in 1829, his appointment carried with it the speakership of the Legislative Council and the presidency of the Executive Council. Henry John Boulton clambered up the ladder behind Robinson, and in 1830 he was elected to represent Niagara in the House of Assembly. Henry John, a man with a brilliant brain and short fuse, was involved in a scheme to build the Welland Canal and the proposed Bank of Upper Canada, for which he received handsome fees. Another Boulton brother, George Strange, established a lucrative law practice in Cobourg, and dabbled in colonial politics. A third brother, William, found a comfortable sinecure as classics master at the newly founded Upper Canada College, at a salary of 300 pounds a year.

The rising fortunes of the Boultons were typical of the colonial elite. By 1831, York was a boom town: the population was close to 4,000 and it would more than double in the next three years, as immigrants poured in from Britain. On weekdays, there were plenty of moneymaking opportunities for the powerful. And on Sundays, "our society" gathered at St. James' Church on King Street to have their faith in God, the King, the Anglican Church and themselves reaffirmed. Sarah Anne, D'Arcy and their children took their places in the Boulton pew under the stern eye of Archdeacon John Strachan, whose linen cuffs were as starchy white as his conscience. In Strachan's era, no one saw any conflict between the Archdeacon's spiritual role and his membership in the Executive Council and the Legislative Council of Upper Canada.

There were still a few surprises that landed gentry back in Britain never faced. Soon after the Boultons' sixth child was born, according to the nineteenth-century writer Henry Scadding, a native Indian wandered into Sarah Anne's bedroom, where she was lying with the baby. Scadding claimed that the visitor simply patted mother and child, said, "Pretty squaw, pretty papoose," and walked away. (Given that

6. Spadina House, home of the reform-minded Baldwins, depicted in a watercolour c.1912 by Frederic V. Poole.

7. William Lyon Mackenzie (1795–1861), "Little Mac" to his supporters and "Reptile" to his critics, portrayed by J. W. L. Forster, 1903.

Mississauga Indians, only thirty years earlier, had roamed freely across empty acres where York now stood, his generosity was exemplary.) And the Boultons had to deal with a tragedy common to almost all families of their era: the premature death of a child. Their eldest boy died while he was still in his teens. But their four remaining sons, particularly William Henry and D'Arcy Edward, grew into strapping young men who, their parents happily anticipated, would preserve the family name and The Grange's pre-eminence for the future.

For all their wealth and sense of entitlement however, Boulton fortunes were not as secure as Sarah Anne might have assumed. By the end of the 1820s, Upper Canada's oligarchy had earned itself some influential enemies who gave it a pejorative label: "The Family Compact." "Our society," of which she and her circle were so proud, was riddled with snobbery and what we would call influence peddling, and was an easy target for contemporaries with more progressive views. Far from being a benevolent aristocracy, too many members of the Family Compact put their own interests well ahead of those of a colony struggling to establish itself in an unforgiving landscape.

Most of Sarah Anne's circle turned a deaf ear to the clamour for better roads and more representative government that was brewing in the rural communities of Upper Canada and the print shops of York's newspapers. "Reptiles!" hissed John Beverley Robinson, when he heard the names of his political opponents. "Spaniel dog," spat Christopher Hagerman, the new solicitor general, at the mere mention of the most prominent agitator, the fiery newspaper editor William Lyon Mackenzie. In 1826, a bunch of wellborn young rowdies led by Sam Jarvis broke into Mackenzie's office, where he published *The Colonial Advocate*, smashed the press and threw the type into the lake. Sarah Anne must have been relieved that her high-spirited sons were still too young to be listed amongst the miscreants.

Not all York's leading families were quite as resistant to democratic ideals as Robinson and Henry John Boulton. At Spadina, the Baldwin family relished intelligent discussion about whether the colony's destiny should be controlled by its own citizens or the Westminster authorities. Old Dr. Baldwin knew that Upper Canada could not insulate itself

from either the constitutional debates rippling through the United States, or the agitation for parliamentary reform in Great Britain. He also recognized that the colony's development would stall unless more money was invested in roads, canals and communications. When he announced his sympathy for Canadian reformers, however, the elite's old guard treated him as a traitor to his class. "[Dr.] Baldwin is certainly mad," remarked Robert Stanton, the King's printer who was a former student of Strachan and friend of D'Arcy, "and will soon require shaving and blistering. His son Robert has lowered himself in the estimation of all sensible persons."

But the power that the Family Compact had managed to concentrate within itself was already starting to slip away: the Boultons, Robinsons, Strachans and their ilk were on the wrong side of history. William Lyon Mackenzie found an ever-widening circle of readers in Upper Canada for his polemics against the Family Compact's despotism. He alerted the government in Westminster to the grievances that festered in their Canadian colony. And with relentless energy, he went after the Boultons who, he raged, "never forget number one."

The worst year in Sarah Anne's life was probably 1834. At one level, family life continued as usual: balls at Government House, concerts by the band of the 79th Regiment, expeditions to Niagara Falls on the steamer that made thrice weekly trips across the lake. She continued to entertain at The Grange, and decided to build on the east side of the house an elegant glass orangery, where she might grow melons and grapes.

At another level, however, she could see that Boulton influence was unravelling. The previous year, her brother-in-law Henry John was dismissed from his post of attorney general because he had ignored the wishes of the colonial secretary in Westminster and condoned the expulsion of Mackenzie from the Legislative Assembly. "How are the mighty fallen," crowed Mackenzie. The Reformers were well and truly in the political ascendancy. In March 1834, the little town of York was incorporated as a city, and returned to its original Indian name of Toronto ("as being more musical," William Boulton explained). In the city's first mayoralty race, none other than the firebrand Mackenzie

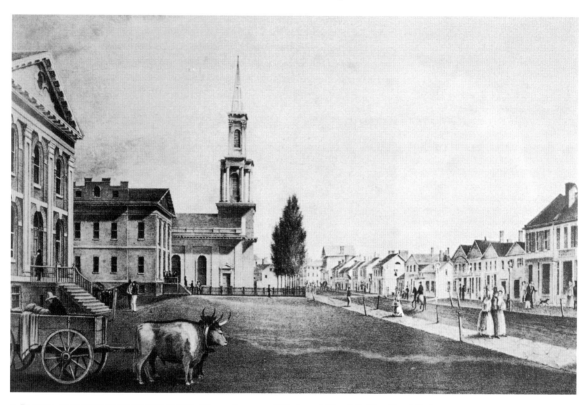

8. By 1835, when Thomas Young depicted the jail, courthouse and St. James' Church in King Street East, Toronto had become a busy commercial centre.

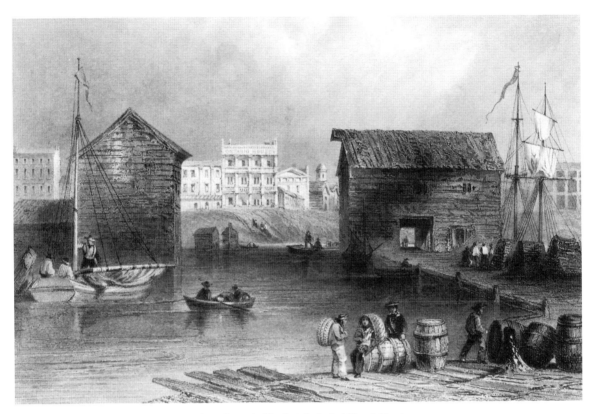

9. Both sailboats and steamers unloaded goods on Cooper's Wharf, at the foot of Church Street, depicted in a Bartlett print in 1841.

himself was elected mayor by his fellow councillors. Around the same time, Sir John Colborne, the lieutenant governor, abruptly cut off D'Arcy's salary as auditor general of Land Patents. D'Arcy was outraged: "I have a large family to educate and maintain," he wrote to Colborne, "and I have certainly not been by any means insensible to the inconvenience of being unexpectedly deprived of a source of income which I supposed was secure."

Personal tragedy followed political setback. In May, the family suffered two grievous losses under Sarah Anne's roof. D'Arcy Boulton Senior, the old patriarch, passed away aged 75. A week later his 30-year-old son William succumbed to pleurisy, leaving Fanny and four children including newborn twins. It was enough to plunge D'Arcy Junior into depression. "Mr. Boulton is also ill," Sarah Anne wrote to Fanny. "He has been very sick in consequence, we think, of anxiety and fatigue, he was much distressed at the sufferings of his father and brother."

But D'Arcy had no time to grieve. By midsummer, a cholera epidemic was raging through York, the second in two years. Sarah Anne hardly dared step out of her house, for fear of the brutal disease, which afflicted its victims with violent diarrhea, vomiting, cramps and death within twenty-four hours. Cholera killed one in twelve of Toronto's citizens that year. D'Arcy was the unpaid chairman of the largely ineffectual Board of Health. There was little the Board could do, in an era of scanty medical facilities, when people drank lake water in which manure and dead horses, cats and dogs were dumped. That didn't, however, stop public criticism of D'Arcy. One consolation was that Toronto's first mayor also reaped public outrage: William Lyon Mackenzie was out of office within a year. But this allowed him to return to his wild rants in *The Colonial Advocate*. "Look up, reader, and you will see the branches — the Robinson branch, the Powell branch, the Jones branch, the Strachan branch, the Boulton twig &tc. The farmer toils, the merchant toils, the labourer toils, and the Family Compact reap the fruit of their exertions." In December 1837, Mackenzie led a ragtag army of rebels down Yonge Street in a badly planned rebellion against the Family Compact. The Boultons went to ground in The Grange. "There was no visiting here this New Year," noted their Queen

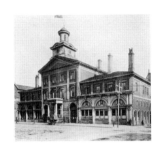

10. The centre block of Toronto's 1844 City Hall boasted a domed cupola and arcaded wings.

Street neighbour, John Macaulay. "Nobody seems disposed for that or for any dinner parties."

D'Arcy was now over 50, and he was tired. His health declined; his business faltered and his only interest seemed to be his son William's colts cantering around The Grange's paddock. He barely knew the town in which he had spent most of his life. Toronto was rapidly transforming itself, once again, from a government centre (Kingston became capital of the newly united Canadas in 1841) to a bustling commercial city dominated by bankers and merchants. The population had grown to some 21,000 residents, nearly a third of whom were Irish. The main streets were gas lit, sewers were laid, and a proper waterworks was opened. By the 1840s, the stench from breweries, charnel houses, glue factories and tanneries had replaced the old aromas of freshly cut wood and pine resin. There were grandiose new civic buildings (a stone jail, a city hall on Front Street, a handsome headquarters for the British Bank of North America) and Gothic churches, such as St. Michael's Roman Catholic Cathedral. The Grange already seemed like a relic of a past era. So did D'Arcy, now suffering, according to his relatives, from "a long and enfeebling illness." In April 1846, his heart gave out.

D'Arcy left Sarah Anne and five adult children. (His eldest daughter Mary had died in childbirth in 1837.) They were land rich and cash poor, and urban development was nibbling at the fringes of The Grange's acres. William, the eldest of the three surviving sons, was now master of The Grange and the titular head of his mother's household. Still single at 34, he had already slotted effortlessly into the colony's governing class. He was a lawyer and a local alderman; he had recently been chosen by his fellow aldermen to be mayor; he had been elected to represent Toronto in the new parliament of the united Province of Canada (a union of present-day Ontario and Quebec), which met in Montreal. An active member of the Orange Order, a rabidly Protestant association with its roots in Ireland, William straddled the patrician values of his Family Compact origins and the new populist Toryism of Orange chieftains.

Yet Sarah Anne knew her own son too well. Indifferent to the disapproval of his former schoolmaster John Strachan, now enthroned as bishop of Toronto, William Boulton was fond of the bottle and the

theatre. He was also a gambler and a bit of a peacock. His major preoccupations were the Racquet Court and Royal Baths he had built on King Street, and the St. Leger Racecourse he had laid out on the northern edge of his property. There was a slipshod disorder to William's business affairs, particularly his speculative land deals. His commitment to civic duty did not extend much further than commissioning a handsome portrait of himself, sitting in the mayor's chair and wearing black court dress, an embroidered waistcoat and silk stockings. He lacked the instincts to be either the civic leader his grandfather had been, or the astute businessman his father was in his prime. His 57-year-old widowed mother knew that she would have to watch her rakish, charming son carefully if The Grange was to retain its reputation for gracious living.

11. William Henry Boulton, depicted in his civic finery by the well-known Toronto society portraitist George Theodore Berthon, was elected mayor of Toronto four times. AGO, Goldwin Smith Collection, bequest of 1911.

Part II: The Two Mrs. Boultons 1846–1875

William Boulton caught his mother off-guard in 1846, seven months after his father's death. Excusing himself from civic duties, he took a trip to Boston. When he returned to The Grange, just in time for Christmas, he was not alone. At his side was a tiny, beautiful young woman with huge dark eyes, translucent skin and a heart-shaped face. Harriette Mann Dixon was the daughter of a wealthy East India merchant who lived at one of Boston's best addresses and was that city's consul general for the Netherlands. It is not clear whether William already knew her before his 1846 trip to the eastern seaboard, or whether, during his short visit, he had wooed and won his 22-year-old bride within a matter of days.

Sarah Anne probably regarded her daughter-in-law with mixed feelings. A wife should settle William down, but a daughter-in-law might challenge Sarah Anne's domestic authority. She need not have worried. For the next 17 years, The Grange's two mistresses appear to have co-existed in harmony. Perhaps the young Bostonian, unfamiliar with Canadian ways, simply deferred to a formidable mother-in-law with strong views on "how things were done". (Sarah Anne grew increasingly imperious as the years passed. When Mrs. Mann Dixon

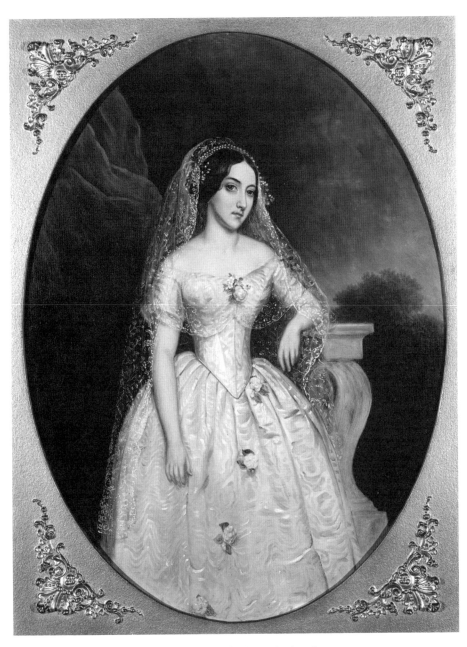

12. The exquisite Harriette Dixon Boulton, painted by Berthon at the time of her marriage, deferred to her formidable mother-in-law. AGO, Goldwin Smith Collection, bequest of 1911.

arrived from Boston for visits, Sarah Anne charged Harriette's mother $100 a month rent for the back bedroom.) More likely, the harmony arose from a shared purpose: to keep William out of trouble, and The Grange in Boulton hands.

William's exuberance kept him in the public eye throughout the middle of the nineteenth century. After a depression in the late 1840s, the tempo of Toronto's growth had picked up again. The city was beginning to look increasingly like the mid-Victorian industrial metropolises of the old country: cities like Manchester and Sheffield, with chimneys belching out black smoke day and night, and huge machine presses rumbling and roaring. The railways had arrived, and with them an acceleration of trade within the Canadas. Lumber and grain piled up on Toronto's wharves, for shipment east and south, while steamers disgorged an endless supply of goods stamped "Made in England." A new mercantile elite arose, largely composed of Scots with no time for Family Compact pretensions. William wanted a share of the action.

At first, it seemed that William would ride the wave of prosperity while maintaining the reputation of his family and home. He had a louche appeal to Toronto voters. His habit of taking a glass of brandy to the podium, while campaigning for the Province of Canada parliament, endeared him to a hard-drinking populace — especially the Orangemen among them. His fellow aldermen admired his Tory values and philanthropy: the Boultons had donated land as a site for a new market in the west end of the city, and for the Church of St. George the Martyr. The city council made William mayor in 1845, 1846 and 1847. Thanks to his connections, he was frequently invited to sit on the boards of directors of railway companies, insurance companies and building societies.

Boulton fortunes appeared as buoyant as ever. William made extensive alterations to the interior of The Grange. He enlarged the downstairs hall and commissioned a new staircase from the engineer Sandford Fleming (for which he paid 10 pounds). In the hall's north wall, he installed a magnificent new window with a painted depiction of the Boulton family crest in the middle and a blue glass border. On the second floor, he created a large assembly room, suitable for evening balls. He also added a two-storey wing on the west side to create an office for

himself, and an additional greenhouse for espaliered peach trees. There were plenty of imposing Victorian mansions in Toronto now, particularly along Yonge Street, but The Grange's Georgian elegance more than held its own.

And the hospitality continued to flow. There were summer picnics, and balls throughout the year at which officers from the British garrison strutted about in their tight trousers. With the first good fall of snow, Sarah Anne organized sleighing parties. Guests, bundled up in furs and covered in buffalo blankets, would rattle down the Kingston Road in horse-drawn sleighs, then return to The Grange for refreshments. When Lord Elgin, governor general of the Province of Canada, announced he would make an official visit to Toronto in October 1847, William invited him to be his guest for the weekend. No one could have been prouder than Sarah Anne, as she received Queen Victoria's personal representative at The Grange's front door, and presided over the dining table the same evening. It was quite like old times. Bishop Strachan said grace. Lord and Lady Elgin chatted with Sarah Anne's brother, Chief Justice John Beverley Robinson. William produced some of his father's best claret. After three days of Boulton hospitality, Lord Elgin confided that he wished Toronto rather than Montreal was the colony's capital. "He felt for the first time in Canada," reported a young lawyer called Larratt Smith, "that he was in an English town, surrounded by English and loyal hearts."

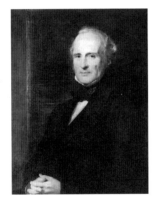

13. Chief Justice Sir John Beverley Robinson (1791–1863), Sarah Anne's patrician brother, portrayed by George Richard c.1855, played a leading role in the colony for 50 years.

But William always sailed too close to the wind. After the Elgin visit, it was revealed that the mayor had splashed out 120 pounds of Toronto council funds for lavish triumphal arches, without official authorization. (At that time, both pounds and dollars were legal tender in British North America.) "Mr. Boulton," thundered George Brown, editor of the reformers' newspaper, *The Globe*, "is an energetic, sharp, ambitious man — but without principle or steadiness of purpose." A few months later, William's law firm, Gamble and Boulton, was discovered to have misappropriated funds that belonged to its clients, including the Bank of Upper Canada, and to be carrying large debts for which it had inadequate collateral. Further investigation revealed that William Boulton personally owed the Bank of Canada nearly $16,000 (the equivalent

today of roughly $3,000,000). William's partner Clark Gamble, who was unaware of his partner's dealings, quickly dissolved the partnership. William Boulton found himself facing some very angry creditors.

It must have been a shamefaced William Henry Boulton who acknowledged to his wife and mother what had happened. Thanks to these two women, however, The Grange was not put on the auction block. Harriette had a comfortable annual income of $10,000 from a trust fund set up by her family. Payments from this source, plus loans from Harriette's brothers, helped to blunt some of the creditors' rage. And Sarah Anne embarked on complicated financial dealings within the family to ensure that William's creditors could never get their hands on Boulton capital or land. By the time she had finished, several acres of Grange property had been sold or mortgaged to pay off William's more pressing debts, and The Grange itself was held in trust for Harriette, "free from the debts and control of her husband for and during her natural life."

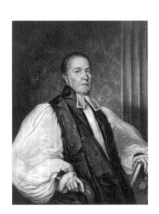

14. Bishop Strachan (1778–1867), schoolmaster and spiritual leader for Toronto's first autocrats, portrayed by Berthon in 1843. AGO, gift of Arthur C. Neff, Toronto, 1934.

Though The Grange was salvaged, William's reputation was irrevocably stained. "This Mr. Boulton," noted his erstwhile guest, Lord Elgin, "has misconducted himself. He is a person of no influence and has not a chance of being returned for the city." Nevertheless, William made a bid for popular support by a shameless appeal to racist sentiments. The French citizens of Lower Canada, he thundered in one of his three-hour public speeches, were "tobacco-smoking, dram-drinking, garlick eating, foreign in blood, foreign in race and as ignorant as the ground they stand upon." He later made an unexpected conversion to the idea of responsible government. The tactics allowed him to hang on for a while; he retained his seat in the Legislative Assembly in 1847, and in 1851 he was re-elected to both the Montreal Parliament and the Toronto City Council.

Within months, however, William's parliamentary election was disallowed because of his erratic business affairs, and he resigned from the council after a row with the mayor. He continued to run in provincial and municipal elections, and apart from a brief spell as mayor in 1858, he continued to be beaten. Even his critic George Brown of *The Globe* marvelled at his persistence: "He is a perfect miracle of courage

and endurance — might we not say impudence and effrontery." During his final campaign in 1863, William tried to speak to a rowdy crowd from the door of Wright's Tavern, on the corner of King and Parliament Streets. His words were drowned by derisive yells from his audience, who hooted with laughter at the nerve of "Guzzling Billy."

During all her son's ups and downs, Sarah Anne ensured that The Grange kept its dignity. Geraniums, roses and pansies from The Grange's flowerbeds, cabbages, potatoes and kidney beans from its vegetable garden, and melons and grapes from its greenhouse won awards at local horticultural shows. Toronto's gentry still treasured invitations to tea from this "beautiful old lady, with silver hair and a placid, chastened, refined face," as a contemporary remembered her half a century later in *Saturday Night.* In 1852, Sarah Anne allowed Grange land to be used for the Provincial Horse Show. When the Prince of Wales visited Toronto in 1860, the Boulton clan assembled on The Grange's lawns to watch him plant three trees. "This fine old house," recalled Sarah Anne's contemporary in *Saturday Night*, "was the centre of all that is gentle and sweet and wise and wholesome in Society."

Sarah Anne Boulton died, aged 74, in 1863. William outlived his mother by eleven years. He spent these final years practising law, and enjoying a home that Harriette made a tranquil refuge from the rough-and-tumble of Canadian politics. During William's lifetime, a new country had emerged. There had been a giant party at Queen's Park, with fireworks and ox-roasting, when the Dominion of Canada was inaugurated on July 1, 1867. To the north and west of The Grange there were still open fields, but King Street, once a muddy lane on which his father had a dry goods store, was now a wide street lined with paved sidewalks and fashionable shops. There were even horse-drawn street-cars rolling down Toronto's main streets, although the city had explicitly forbidden them to run on Sundays. Theatrical performances, newspapers and concerts were also unavailable on the Sabbath. Bishop Strachan might be in his grave, but his forbidding influence lingered in a city that now boasted over 50,000 residents.

William Boulton died on February 1, 1874, leaving no heirs. His well-attended funeral at St. James' Church triggered a rush of affection

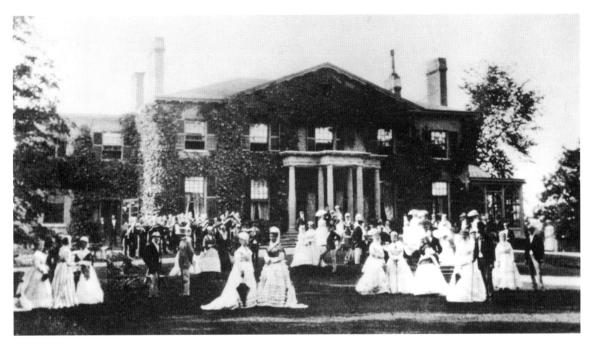

15. The annual garden party at The Grange, photographed in 1880, was a highlight of the Toronto season.

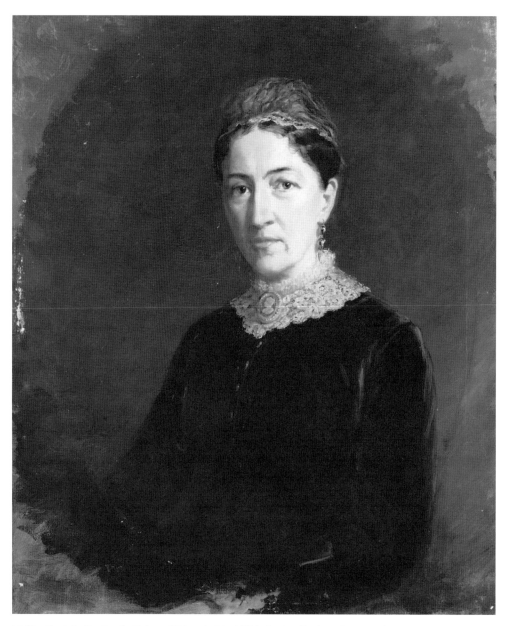

16. Mrs. Harriette Boulton Smith in an 1884 portrait by J. W. L. Forster. She knew her cantankerous
second husband, Goldwin Smith, had a gentler side. AGO, Goldwin Smith Collection, bequest of 1911.

for the former mayor, who had clung to eighteenth-century assumptions amid the nineteenth-century bustle. His public self, suggested the conservative *Mail*, "was strangely at variance with his habitual frame of mind, for at home and in private life a gentler or more amiable gentleman was seldom seen."

By the time of William's death, Toronto was slowly emerging as a cultural centre. Both the great Italian diva Adelina Patti and the Swedish nightingale Jenny Lind had given concerts in St. Lawrence Hall. The portraitist George Theodore Berthon, whose father was court painter to the first Napoleon, had made Toronto his home. Dr. John McCaul, president of King's College and later of University College, was tireless in organizing choral concerts. At the Royal Lyceum, on King Street, Italian opera and English plays were regularly performed. No one ever accused the Boultons of being intellectuals (although in 1852, the two Mrs. Boultons lent some of their paintings to an art exhibition in the parliament buildings). But Harriette Dixon Boulton, the new mistress of The Grange, enjoyed art, music and theatre. On trips to Europe (including an extended tour with William in 1857) she had studied Renaissance masters in Florence's Uffizi Gallery, and painted copies of two Titians. In the years to come, thanks to her and the man who would become her second husband, some of Toronto's liveliest minds would continue to value invitations to The Grange.

Part III: Mrs. Harriette Dixon Boulton Smith and her legacy 1875–1918
In 1874, Harriette Boulton was no longer the wide-eyed, fragile young woman who had arrived at The Grange almost twenty years earlier. Her fiftieth birthday approached, and both her face and her figure had filled out. She was widely admired within Toronto society for her warm manner and the enduring love she felt for her rogue of a husband. Yet she had rarely taken a financial decision for herself. While her husband had swaggered around as though he was in charge, her own family kept control of Harriette's considerable fortune. If Thomas Dixon, her father, had not carefully tied up her money, Homer Dixon told his sister, "every shilling of it would have gone to pay William's debts."

After her mother-in-law's death, Harriette had assumed responsibility for the household staff of nine (butler, assistant butler, yardman, coachman, gardener, cook, parlour maid, housemaid and lady's maid), most of whom lived on The Grange grounds in three cottages. Her English butler, the invaluable Mr. Chin, could be relied on to help her decide what to plant, buy, cook or serve. But Harriette was ill equipped to handle the legal complications involved in settling William's estate. She lashed out at her brother Homer, who had moved from Boston to Toronto in part to keep an eye on "dear Hat" and her unreliable husband. In 1875, Harriette accused Homer of trying to claim ownership of The Grange for himself and their brother FitzEugene. Homer, who had held his tongue as he watched his late brother-in-law waste Dixon money, was outraged by the charge. "This is utterly false!" he wrote Harriette.

Then an unlikely peacemaker emerged in the person of Goldwin Smith, an austere English man of letters. Even the cream of Toronto's business and political establishment treated the haughty old Etonian with respect bordering on awe. Hadn't this tall, elegant figure once been regius professor of history at Oxford University, where he had been the Prince of Wales's personal tutor? Did he not work alongside Thackeray on the *Saturday Review,* and dine with Dickens at the Athenaeum Club? Hadn't he been one of the first professors at Cornell University, the newly established centre of learning in the raw wilderness of Ithaca, New York?

Goldwin Smith had been all of these. The surprise was that he had settled in Toronto. Smith was that curious creature: a patrician with progressive views, who liked to style himself as a man of the people although he rarely sat down with them. Frustration with the dead weight of tradition and the class system had driven him from England, but Ithaca's bleak landscape had been too much for him. Some years earlier, however, he had visited his cousin Mrs. Colley Foster in Toronto and was attracted by Canada's mix of British values and American energy. William and Harriette Boulton invited him to dine at The Grange: in this most English of North American houses, Goldwin Smith apparently felt completely at home. So in 1871, he made a permanent move to

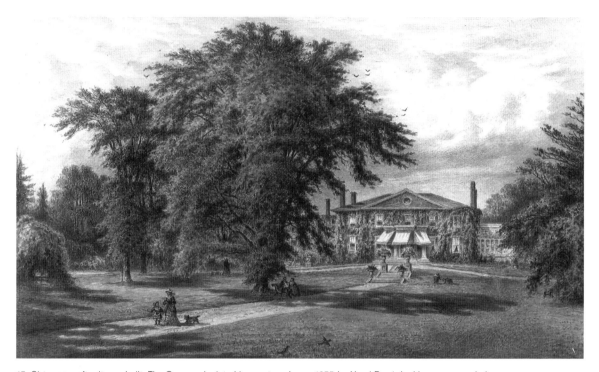

17. Sixty years after it was built, The Grange, depicted in a watercolour c.1875 by Henri Perré, had become a symbol of graceful tranquillity within a bustling city. AGO, Goldwin Smith Collection, bequest of 1911.

Toronto, where he threw himself behind a nascent nationalist movement, began to write fiery articles for the press, and renewed his acquaintance with the Boultons.

In the summer of 1875, Goldwin Smith walked from his home on Spadina Avenue to visit the widow Boulton. Now 52, he had hitherto shown little interest in the opposite sex. At Cornell, his aristocratic lip had curled at the mere mention of co-education: the university's decision to admit women was an element in his decision to leave it. Harriette's dimpled smile and sweet vulnerability must have aroused an unexpected chivalry in her guest. He offered to help her sort out her affairs, and was soon acting as mediator between Harriette and her brother. And on October 1, 1875, with Homer Dixon as best man, Goldwin Smith and Harriette Boulton were married at St. Peter's Church.

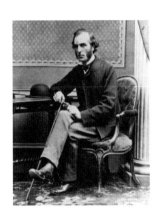

18. Goldwin Smith c.1880 was dapper, opinionated and wealthy.

Smith himself was a wealthy man (in 1887, his personal fortune amounted to $355,840), so he did not marry Harriette for money. And Harriette had little interest in Goldwin Smith's ideas. She stayed aloof from his polemics against the British Empire, as well as those in favour of annexation by the United States and the secularization of public life. Yet the marriage that Smith initially described, in a letter to his friend Charles Norton, the distinguished Harvard professor, as "a union for the afternoon and evening of life" turned out to be a 34-year-long partnership of unusual affection. Harriette was the kind of woman who enjoyed devoting herself to a husband's welfare; she had, after all, endured widowhood for less than sixteen months. She made the perfect wife for Goldwin Smith, thanks to their shared conviction that he was a great man.

No diaries or letters in Harriette Boulton Smith's own hand have survived to allow us a direct encounter with her. But it is obvious that from the first weeks of the marriage, she organized The Grange's routine around Goldwin Smith. The former academic had already turned himself into a prolific and controversial journalist, who preferred to establish his own journal rather than tolerate unsympathetic editors elsewhere. In 1872 he had launched the *Canadian Monthly and National Review*, a journal of literature and politics, in which he aired his fiercely partisan views under the nom de plume, "A Bystander." In addition he

contributed both funds and articles to *The Nation*, the short-lived organ of the nationalist "Canada First" movement, and to a new daily newspaper, the *Evening Telegram*. In the years ahead, there were a series of rows with editors, new publishing ventures (including *The Week* and the *Bystander*) and a flood of articles in the international press. Scarcely a Sunday went by for three decades without a letter from Smith in the *New York Sun*.

Goldwin Smith had views on everything, from the need for free trade, Sunday streetcars and city parks to the dangers of income tax, old age pensions and publicly financed education. He expressed them in vigorous arguments and bitingly clear prose. Perhaps it was just as well that Harriette paid little attention to her husband's opinions, since many of them were patently offensive. His confident assumption of Anglo-Saxon superiority led him to despise other races: the Irish, native North Americans, Jews, French Canadians. Although he was a strong supporter of benevolent societies and boys' clubs, he opposed free lending libraries. "A novel library," he told Andrew Carnegie, "is to women mentally pretty much what the saloon is physically to men."

Goldwin Smith was a crank, but when all was said and done, his presence in Toronto galvanized intellectual and cultural activity. His interests were primarily literary. He founded journals that would publish the work of the first generation of all-Canadian poets, such as Archibald Lampman, Isabel Valency Crawford and Pauline Johnson. Thanks to Smith, British literary stars, such as the poet Matthew Arnold, the writer Arthur Conan Doyle and the biographer John Morley, included Toronto in their North American speaking tours, so they could be guests at The Grange.

But Smith did not ignore the visual arts. He supported the determination of young Canadian artists, such as Marmaduke Matthews, T. Mower Martin, Frederick Verner and Lucius O'Brien, to paint Canadian, rather than European, subjects. The post-Confederation generation of artists had few opportunities to discuss technique, let alone see or show original indigenous work. The only public display of sculpture and paintings in the province was a ponderous collection of copies of European masterpieces, on display since 1857 in the Toronto

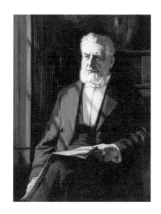

19. In 1911, the invaluable Mr. Chin, butler at The Grange for over half a century, was painted by Paris-trained George Agnew Reid, who had lobbied for an art gallery in Toronto. AGO, gift of the artist to commemorate Chin's long association with The Grange, 1934.

Normal School. The leading commercial gallery in early 1870s Toronto belonged to dealer James Spooner, who combined his showroom with a tobacco shop and a dog kennel. But this began to change after 1872, with the arrival in the city of John Fraser, an energetic Montreal painter who missed the artistic camaraderie of his former home. Fraser had worked in Montreal with the photographer William Notman and came to Toronto to establish a photographic studio that he ran in partnership with Notman.

Fraser provided both momentum and a meeting spot for the city's young artistic community. He founded the Ontario Society of Artists, and the OSA's first exhibition in 1873 was held in the Notman-Fraser Galleries. He also pushed the OSA to establish a school of art in 1876, but attempts to find funding and permanent space for a public gallery foundered. The provincial government was prepared to buy Canadian art: it gave the OSA an annual grant of $500 for paintings to be hung in public buildings, and it commissioned portraits and sculptures of lieutenant governors and premiers. But politicians were not convinced that art appreciation was a public responsibility. So during these years, many local artists were obliged to show their depictions of Canadian wilderness, history and native life in makeshift showrooms, or alongside pumpkins and fancy needlework at the annual provincial exhibitions. Smith attended artists' openings and, after the Royal Canadian Academy was founded in 1880 under the presidency of Lucius O'Brien, he bought works by Canadian academicians. Portraitist John W. L. Forster painted both Harriette and, on three different occasions, Goldwin Smith himself. (Smith had protested, according to Forster, that "it was useless to attempt to paint a wreck.") His bony features and high cheekbones were also immortalized in oils by Wyly Grier and in white marble by Hamilton McCarthy, and the prominent sculptor Walter Allward, who went on to design the Vimy Monument, made a death mask of Smith.

The city's intelligentsia respected Smith's abilities and his insistence that Canadian culture should be encouraged, even if they found his opinions hard to swallow. They smiled courteously at his frosty condescension. Hector Charlesworth, the future editor of *Saturday Night*,

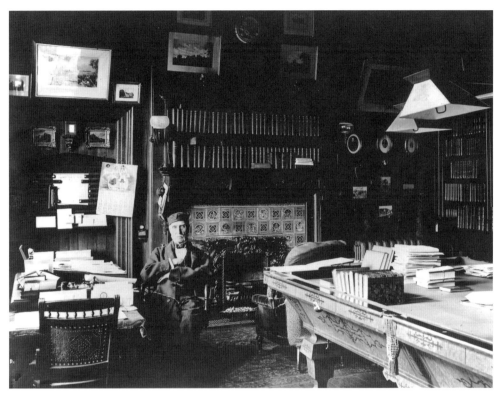

20. The billiard table c.1900 in Goldwin Smith's new library was always covered in books.

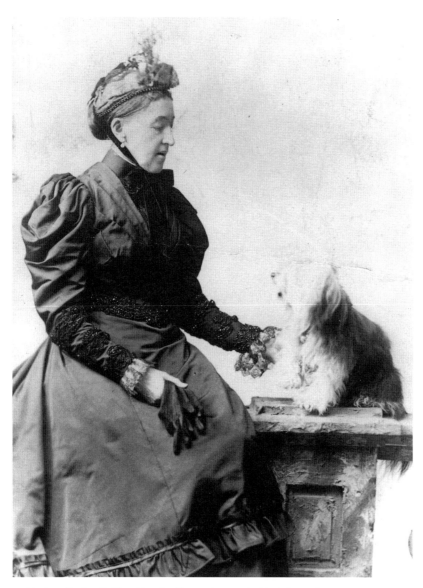

21. Harriette Boulton Smith and her dog Flossy, photographed by J. Fraser Bryce c.1895.

recalled with amusement "how people used to mention his views and utterances almost with bated breath, and thrust him into the limelight on every public occasion." Sometimes he went too far; in 1895, for example, a biting attack on Sir John A. Macdonald prompted this response in the columns of *The Week*:

Oh Goldwin Smith! Oh, Goldwin Smith!
How came you to belittle
The memory of our hero with
The venom of your spittle!

We're perfectly aware that he
Had weaknesses and failings,
But will the course of History
Be altered by your railings?

We fear it is a grudge you bear;
He built us up a nation,
And thus postponed for many a year
Your scheme of Annexation.

Within The Grange, however, the private Goldwin Smith was a far warmer character than his forbidding public style suggested. In later years, his butler Chin described his employer as "a perfect gentleman, thoughtful, kind and considerate." An officer of the Humane Society, Smith was hopelessly sentimental about animals. He would not allow his coachman to dock the tails of his horses; he insisted that a tap was kept running on the front lawn to provide water for thirsty birds; he was outraged by rumours that the elephants in the Toronto zoo were ill-treated. He and Harriette doted on Flossy, a Skye terrier he gave his wife: Smith penned a poem entitled "From Flossy to her mistress." ("Of all the tiny race of Skye/The prettiest, so friends say, am I.") This was the Goldwin Smith that Harriette knew, and for whom she provided the security and steady daily rhythm that allowed him to devote himself to his writing. In return, he showed her a sweet solicitude. He read aloud

to her while she sewed; he was endlessly courteous with her guests. The marriage, he wrote at the end of his life, was "the happiest event of my life. Whatever might happen to me outside I was supremely blest in my home."

In the early years of his marriage, Smith used as his study William Boulton's office on the west side of the house. But the room soon overflowed with all the books, papers and correspondence required for his provocative punditry. And since the Boultons had never been readers, there was nowhere in The Grange for the largest item in Smith's baggage: his vast library. In 1885, Harriette and her husband decided they needed to extend The Grange to accommodate his needs. So they pulled down the greenhouse, in which William had grown his espaliered peach trees, and added a new wing. The architect for this extension was Walter Strickland, nephew of Susanna Moodie. From the outside, the wing appeared to be two storeys, so that it blended into the Georgian facade, but inside it consisted of one large room with a high ceiling. It had floor-to-ceiling bookshelves (all overflowing within months of completion), a fireplace surrounded by Minton tiles depicting scenes from Shakespeare, and French doors opening onto the smooth lawns and old elms of The Grange's grounds. Smith worked at a desk, or stretched out his long legs as he sat and read in a comfortable low chair by the coal fire. A favourite quotation from Cicero was carved in a scroll over the fireplace: "magna vis veritatis, quae facile se per se ipsa defenda" (great is the power of truth, which can easily defend itself by its own force).

While the library was being built, the Smiths made additional changes to the mansion, now tagged "the oldest brick house in Toronto". They installed a heavy angular staircase leading from the main hall to the bedroom floor. They put stained glass in the windows by the front door, and laid Persian rugs on the polished floor. On the east side, they tore down the old orangery and added a verandah. In the dining room, Smith hung gloomy portraits of his intellectual heroes — all Puritans from the seventeenth century — writers John Milton and John Bunyan, and parliamentarians John Hampden and John Pym. Some of the Smiths' changes introduced a ponderous Victorian note into

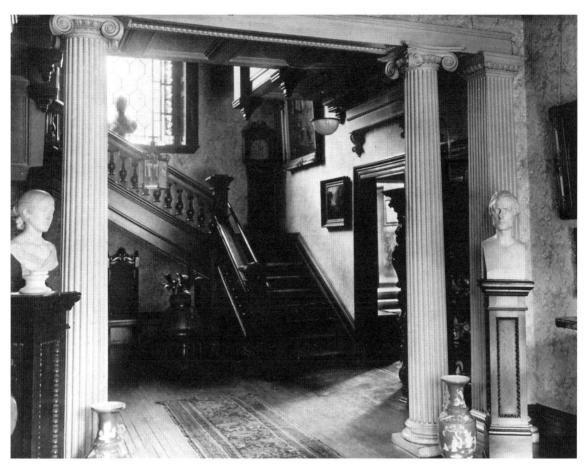

22. The Smiths installed an angular Victorian staircase (photographed c.1910 and since replaced) in their Georgian mansion.

the original airy interior, but The Grange's Georgian facade and leafy grounds remained untouched. It was, confided Smith to a friend, "just like the little mansions on the outskirts of country towns in which some of Miss Austen's characters lived. The city has encircled it, but has left it with ample grounds for one to toddle about, like Mr. Woodhouse in 'Emma'."

By their second decade of marriage, the Smiths had established an unvarying daily routine. Harriette barely saw her husband during the daylight hours and made sure that he was never disturbed. This gave her ample time for her household responsibilities: organizing meals, planning dinners, sending out invitations, issuing instructions to her staff, entertaining visitors, calling on friends. She would take guests out in the open landau, driven by the coachman Stillaway in full livery, to call on the leading matrons of Toronto society in their Romanesque mansions on Jarvis Street, or in the expensive new suburb of Rosedale. Or she would show them the sights: the triple-towered new Union Station on Front Street; the rowing races during the summer months in the harbour; the stores along King Street, such as Walker and Sons, said to be "the finest retailing clothing house in the Dominion."

Meanwhile, Smith followed a strict schedule. He rose hours before his wife: by the time he sat down for breakfast, served to him in the dining room by Chin, he had read all the Toronto newspapers. Immediately after breakfast he went to his library where his secretary awaited him. Graeme Mercer Adam, a Scottish writer, was the first to hold this position, but Arnold Haultain filled it for most of Smith's Toronto years. Smith and "Tabby", as Haultain was called by his employer, worked on Smith's correspondence and compositions until lunch at 1:30 pm. "Their luncheons do not suit me," Haultain once confessed. "The Professor helps himself to rice blanc-mange or 'punkin pie' — the latter is one of his pet dishes; they grow pumpkins on purpose for him. This he washes down with a cup of tea, and his luncheon is over — time about seven minutes." Work then continued until four or five o'clock in the afternoon, when Smith joined Harriette and any guests in the drawing room for afternoon tea. On evenings when the Smiths dined alone, they would play whist or cribbage.

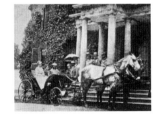

23. Harriette Boulton and her mother Mrs. Dixon, in the Grange landau, c.1860.

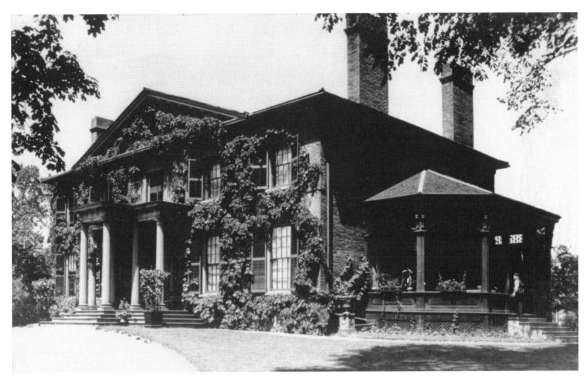

24. The Grange, photographed by William James in 1907, a mansion "in which some of Miss Austen's characters" might have lived.

As Mrs. Goldwin Smith, Harriette particularly enjoyed the frequent trips to Europe with her husband. In 1881, she accompanied Smith on a visit to Liberal Prime Minister William Gladstone at his country estate Hawarden; in 1882, she watched Smith receive an honorary degree at the Oxford encaenia, along with Robert Browning. (Smith's views on poetry were as ornery as those on politics: Browning, in his view, was "a stockbroker, not a poet.") The Smiths crossed the Atlantic several more times, but The Grange was never far from Harriette's thoughts. On her various trips she purchased a new lion-headed brass knocker for the front door, a carpet for the drawing room and a grate for the drawing room fireplace.

For all his rigid working habits, Goldwin Smith was a sociable man. The Smiths preferred to entertain at The Grange rather than plunge into the exhausting rituals of other people's "at homes." Smith abhorred events at which people were crammed "into a hot room and [made to] stand there for hours talking against the buzz to people to whom they did not want to talk, on subjects which they did not want to talk about." There were two or three dinner parties at The Grange each month throughout the winter. According to Chin's pantry book, between 1890 and 1902, Harriette put together 128 dinner parties, 187 supper parties, 47 lunch parties, plus frequent tea parties and the annual garden party. She arranged cultural events in the ballroom on The Grange's second floor: chamber music concerts, or lectures by her husband on English literature. "Mrs. Goldwin Smith invites the right people," *Saturday Night*'s social columnist noted. "The mere sight of the old oak and old china at The Grange gives pleasure." Afterwards, guests would descend to the drawing room, where a white-gloved Chin and his subordinates would courteously offer refreshments from massive silver trays.

In the summer, to cater to her husband's athletic tastes, Harriette organized weekly tennis parties on the lawn in front of The Grange. Smith himself was as competitive with a racquet as he was with his pen, but others came for the lemonade, dispensed by Harriette with characteristic poise. The Smiths' annual garden party each June, at which champagne cup was served to two or three hundred people, was a highlight of the social calendar.

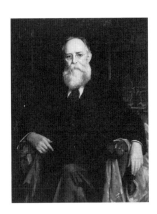

25. Sir Edmund Walker (1848–1924) portrayed in 1921 by Edmund Wyly Grier, was a prominent banker, a member of Goldwin Smith's Round Table and an important collector. AGO, gift of Sir Edmund Walker, Toronto, 1921.

Much as Smith enjoyed playing the country squire, he chafed at his essentially marginal role in Canadian public life. One summer's day in 1896 he poured out his frustrations to his friend James Mavor, professor of political economy at Trinity University, while the two men were walking on Toronto Island. He spoke of the dreariness of Toronto winters and the need for intellectual companionship, and he raised the idea of a dining club that would meet once a month. Mavor approved the notion and suggested it should have twelve members. Until Smith's death, the Round Table dining club met regularly, usually in The Grange dining room. It was a perfect setting for Goldwin Smith, who had always preferred male company and hankered for the Oxford senior common rooms of his youth.

The original Round Table members included Professors Hutton, Wright, Alexander and Clark from the University; James Bain, the city librarian; Oliver A. Howland, Q.C., the future mayor of the city; Canon Welch, rector of St. James' Cathedral; J. S. Willison of *The Globe*; and Byron Edmund Walker, general manager of the Canadian Bank of Commerce. On the appointed evening, Chin would greet by name at the front door each man, plus any eminent visitor to Toronto whom Smith had decided to include in the dinner. (In 1897, Professor Mavor brought along the Russian anarchist, Prince Kropotkin.) With old-fashioned solemnity, Chin would announce each guest at the drawing room door. There Harriette gave her husband's friends a warm welcome, offered them a glass of sherry, then retreated to her needlework. As soon as the company was complete, Smith ushered them into the dining room and seated them under the four Johns in their gilt frames. His voice always dominated the buzz of conversation. "Any dinner party of which he was a member," recalled Maurice Hutton, later principal of University College, "tended to become a monologue. It was rather tragic for him, but inevitable, that no one could stand up to him here as people could in his proper home, Oxford. He was incapable of playing second fiddle."

By now, Goldwin Smith was universally known as "the Sage of The Grange." Although he had persuaded few of his readers on the merits of Canada–US union, or the dangers of lending libraries, the respect accorded to him was undiminished by time. The apogee of his

prominence came in the summer of 1897, on the occasion of Queen Victoria's Jubilee. The annual Grange garden party coincided with a visit to Toronto by the governor general, the Earl of Aberdeen, and his formidable wife, the Countess. Smith had famously dismissed the office of the governor general as being "useless, but as capable of giving harm as the appendix." Nevertheless, the Aberdeens accepted Harriette's invitation to a *fête champêtre* at The Grange. Their Excellencies drove up in an open landau and, in the words of author Sandra Gwyn, "As so often has happened before and since to staunch republicans when actually confronted by royalty, Smith melted as butter in the sun." Lady Aberdeen herself noted that the Sage was "on the doorstep, hat in hand, all the time ready to fetch anyone we wanted to speak to."

Lady Aberdeen was most amused by her host's deference. Once inside The Grange, Smith got out the house's most treasured antiques, the crystal stirrup cups that reputedly had once belonged to John Graves Simcoe, first lieutenant governor of Upper Canada. The stem of each cup was finished with a cut-glass ball instead of a base, since they had originally been designed for drinking on horseback. Nothing would do but that Smith and Lord Aberdeen must drink the Queen's health from them. "Who would have thought the day would come?" the Countess continued in her diary. "It is a curious fact that the man who has been preaching annexation, should also be the man to receive us in the most absolute royal manner, every point of etiquette being most formally observed." But the occasion was in keeping with tradition at The Grange, where the famous footless cups had been produced with equal flourish when Lord Elgin was received in 1847, the Prince of Wales in 1860, and Governor General Lord Lansdowne in 1887.

The parties continued into the new century. Despite their advanced ages (Harriette was 76 in 1900, her husband 77), both were in good health. The Grange had worn as well as its residents. It remained a sanctuary, undisturbed by the clang of the trolley bell (Smith had helped to win the Sunday streetcar battle) or the rattle of carriages on the busy streets. Yet it was now squeezed from every side, as the population of Toronto continued to swell (208,040 residents in 1901) and the city's financial muscle began to challenge that of Montreal. How long could a

26. One of The Grange's two crystal stirrup cups and rinsers, reputed to have been owned originally by the first lieutenant governor of Upper Canada. AGO, Goldwin Smith Collection, bequest of 1911.

verdant seven-acre estate nestled within the downtown core withstand land-hungry builders and developers? The Smiths had no direct heirs, and any attempt to bequeath the property to Boulton and Dixon relatives would involve carving it up. In 1902, Edmund Walker, the banker, approached the Smiths and suggested they consider deeding The Grange to become the home of the Art Museum of Toronto. The proposed museum had been incorporated in 1900 but as yet had no premises.

Pressure for a public art museum had been building for some time. By now, other North American cities of the size and self-importance of Toronto boasted impressive civic institutions. The Metropolitan Museum of Art in New York, the Philadelphia Museum of Art and the Museum of Fine Arts in Boston, Harriette's birthplace, all broke ground in 1870. The Art Association of Montreal's new building in Phillips Place and the Art Institute of Chicago opened in 1879, and the Art Gallery of Detroit in 1885. For the most part, the initiative and funding for these institutions had come from wealthy philanthropists who had two objectives in mind: the formation of permanent collections, and public education through annual exhibitions that would showcase both local artists and works from private collections.

There had been various attempts in Toronto during the 1880s and 1890s to establish a public art gallery. All had been derailed by infighting within the artistic community and conflict over whether such an institution should be located in Ottawa or Toronto. But there was now a developing consensus that Toronto deserved a gallery. The city's wealthiest citizens noticed that prestigious cultural institutions were good for business: cities like Boston, Chicago and Montreal were attracting large numbers of tourists. The intellectual elite was exasperated that the provincial capital was, in the words of the University's Professor Coleman, "the most Philistine city in the Dominion."

At the same time, the city's artistic community had grown in size, skill and verve, and demanded recognition for Toronto as the principal art centre in Canada. In 1879, the Prince Edward Island-born painter Robert Harris had created a stir when he arrived in Toronto fresh from the ateliers of Paris, and introduced a vogue for painting in the grand French manner. French painting in this period was considered the most

27. Goldwin Smith (second from right) assembled the city's intellectual leaders in The Grange dining room in the early 20th century to discuss the future constitution of the University of Toronto. Those present included (left to right) Rev. Bruce Macdonald, principal of St. Andrew's private boys' school; the Anglican clergyman Rev. H. J. Cody; Sir William Meredith, chief justice and chancellor of the University; industrialist and philanthropist Joseph Flavelle; A. H. U. Colquhoun, editor of the Toronto *News*; Smith and Sir Edmund Walker, general manager of the Bank of Commerce.

accomplished in the world; Harris became the model for a new generation of Canadian artists. Painters like George Reid abandoned the Canadian landscape genre, painted in romantic style by Lucius O'Brien and his contemporaries, in favour of large, theatrical, figurative compositions. Reid and numerous others also crossed the Atlantic to study at Paris's École des Beaux Arts. In Toronto, nude models were not permitted in art classes, but in France young Canadian painters could master the human anatomy unencumbered by Ontario's prim morality.

Those inhibitions slowly began to dissolve. In 1890, the young Paris-trained painter Paul Peel held a one-man show in Toronto, which included his seductive canvas *A Venetian Bather*. Perhaps the first nude to be publicly exhibited in the city, it was greeted with acclaim. Peel remained abroad, but Reid returned to Toronto in 1889 and made an immediate impact with huge showy tableaux, such as *Forbidden Fruit*, 1889 and *Mortgaging the Homestead*, 1890, which he exhibited to an admiring public from his studio. He successfully married the academic precision of the Paris Academy with the emotional narratives of rural Ontario. But there was still no public gallery in which his works could be displayed to Toronto's emerging, culture-hungry middle class.

By the century's end, Reid was president of the Ontario Society of Artists and an ardent proponent of the gallery scheme. In 1900, he circulated 2,000 copies of a pamphlet entitled "On the Need of an Art Museum in Toronto" amongst the city's wealthy and most influential citizens. He made sure one copy fell into the hands of Edmund Walker. Walker, in addition to being a prominent banker and a member of Goldwin Smith's Round Table, was a champion of the arts who played a pivotal role in the foundation of the Art Museum of Toronto, as well as the Royal Ontario Museum, the National Gallery of Canada, the Champlain Society, the Mendelssohn Choir and the National Battle-fields Commission. He also served as chancellor of the University of Toronto. He believed, quite simply, that a country without culture was doomed. "What must be the fate of a nation?" he asked in 1910, when he received a knighthood, "which does not give due place to the intellectual and artistic in life?" Yet the origins of the man who would serve as president of the Canadian Bank of Commerce for 17 years could not

have been more humble. Born in a log cabin in 1848 in Upper Canada, he never attended university. Instead, he joined the Canadian Bank of Commerce as a clerk when he was 20. He developed an expertise in the technology of engraving after being tricked by a forger into accepting a counterfeit bill. He went on to build a superb collection of fine prints, primarily intaglio etchings, but also Japanese woodblocks. He also collected fossils, Delft plates, and Chinese and Japanese ceramics. Along the way, he became an expert on subjects varying from entomology, Canadian history, and the poetry of Robert Browning to the Barbizon landscape school. When he died in 1924, the obituary in *The Globe* was headed: "A Giant Oak Has Fallen."

Walker read Reid's pamphlet carefully, and decided to act. By March 31, 1900, he had taken over leadership of the art gallery campaign, formed a committee of like-minded businessmen and intellectuals to pursue the goal, and drafted a charter. Within months, he had also raised about $40,000 from such prominent Toronto families as the Masseys and the Flavelles. At this stage, the campaign stalled. Private benefactors alone could not raise enough money to buy land and build a gallery, and Walker was unable to persuade the ever-reluctant government of Ontario to chip in. So he cast around for another way to provide the proposed gallery with a permanent home. The course of events is not entirely clear, but a match between Walker's campaign and the Smiths' philanthropy was soon evident.

In 1902, the Smiths made up their minds: after their deaths, The Grange should become the home of the new Art Museum of Toronto. Until then, their bequest should remain secret. The following year, the objectives of the proposed museum were outlined in a second bill of incorporation passed by the Ontario legislature: "The cultivation and advancement of fine and applied Arts, the holding of exhibitions, the use thereof by artists and others for art purposes, the acquiring of works of art, the education and training of those desirous of applying themselves to art studies, and generally, by any lawful means, to encourage, promote and further Art interests in the Province of Ontario." The art museum was now a legal body and while it waited for The Grange to become its home, it started holding exhibitions in borrowed

premises. Its first show, an exhibition of Glasgow painters organized by Smith's friend Professor James Mavor, was mounted in the public reference library at College and St. George Streets in 1906. The Art Museum's first acquisition for its permanent collection was one of the canvases from this show, E. R. Hornel's *The Captive Butterfly*, paid for by subscription.

Yet Walker's work wasn't complete. He still had to nudge the provincial government into making The-Grange-to-Gallery project feasible by purchasing and donating to the project the property north of The Grange, which had been sold by the Boultons years earlier. The government dithered as to whether it could justify the investment. In 1907, Smith wrote to Z. A. Lash, the lawyer for the transaction, asking what was the cause of the delay and pointing out he and his wife were not getting any younger.

28. In 1910, seated in the picture gallery at his Toronto home Long Garth, Sir Edmund Walker questioned explorer Ernest Shackleton about his Antarctic adventures.

The papers were drawn up and signed just in time. In late August, 1909, Harriette caught a cold while driving in an open carriage to make some calls. "Ordinarily she possessed great recuperative powers," reported *The Mail and Empire* on 10 September, "but on this occasion her great age told against her and she was unable to conquer her illness." The Sage of The Grange was devastated by the loss. "Would I could be assured," he wrote after her death, "that she had been half as happy in me as I have been in her." Nine months later, he followed her. Cantankerous to the last, he left the bulk of his fortune (over $800,000), not to the city in which he had resided for 39 years, but to Cornell University. His art books were to remain at The Grange, while the rest of the library would go to the University of Toronto.

In 1912, the paperwork was completed and The Grange became the residence of the Art Museum of Toronto. At the same time, the City of Toronto agreed to contribute $5,000 per annum towards its upkeep, and ensured that the public would have free admission to the museum on Wednesday and Saturday each week. The first president of the Gallery's board was Sir Edmund Walker. The first public exhibition held in The Grange, in June 1913, was of the Smiths' own uninspiring collection, including Goldwin's four gloomy Johns and Harriette's Titian copies. But the museum soon established good relations with the city's

29. The Grange gardens, looking south from the front porch, photographed by William James in 1909.

collectors, including Walker, from whom it secured more impressive loans and donations for its temporary and permanent exhibitions. The Grange quickly became home to a wide range of artistic societies. From 1916 onwards, the annual shows of the Canadian Society of Etchers, the Toronto Camera Club, the Toronto Society of Architects and the Ontario Society of Artists were usually held there. As early as 1918, The Grange became the venue for annual exhibitions of student work from the Ontario College of Art. In addition, there were exhibitions within its historic walls of Japanese prints, sculptures by Toronto artists and lithographs from the National Gallery of Canada.

Construction slowly began of proper gallery facilities behind the mansion, and the institution's name was officially changed to the Art Gallery of Toronto to avoid confusion with the new museum being built on Bloor Street. (In 1966, in recognition of its provincial mandate, it was renamed the Art Gallery of Ontario.) On April 4, 1918, the first wing of the projected complex, designed by the architect Frank Darling and consisting of three rooms running along the north side of The Grange, was opened to the public. Sir Edmund Walker wrote in his journal: "Today, after 17 years of effort and disappointment, I had the pleasure in the afternoon of declaring the first unit of the Art Museum open."

Harriette Boulton Smith's generosity and Edmund Walker's leadership allowed The Grange to continue in its old role as a cherished Toronto landmark, and to fill an important new function as a leading cultural institution and a symbol of Canada's growing artistic vigour.

Sources

Much of the material for the history of The Grange came from The Grange's own archives. I found a gold mine there: letters, research and building reports, extracts from family papers, information from legal documents, clippings and (best of all) Mr. Chin's pantry books. I was particularly lucky to be able to rely on material assembled by John Lownsbrough for his lively and helpful publication, *The Privileged Few* (1980). In particular, Lownsbrough had done a thorough examination of newspaper articles for the period 1815 to 1863, on which I drew for information about the Boultons.

For the main dramatis personae of The Grange story, I relied extensively on *The Dictionary of Canadian Biography*. I turned to J. M. S. Careless's *Toronto to 1918, An Illustrated History* (1984) for information about Toronto throughout the nineteenth century. Two volumes of original documents edited by Edith Firth for the Champlain Society, *The Town of York 1793–1815* (1962), and *The Town of York 1815–1834* (1966) and Henry Scadding's *Toronto of Old*, edited by F. H. Armstrong (1966) give the colour and texture of life in York. The list of household goods that Sarah Anne needed, for example, is taken from "Document H39", in Firth's first volume: a catalogue of house contents put up for auction in 1811. There are many assessments of the role of the early Boultons and their friends in pre-1837 Upper Canada: I relied on *The Family Compact: Aristocracy or Oligarchy?*, edited by David W. L. Earl (1967). I also found William Kilbourn's *The Firebrand: William Lyon Mackenzie and the Rebellion in Upper Canada* (1956) useful.

Goldwin Smith's own memoirs were relatively unhelpful sources for the Smiths' years at The Grange. However, I found a wealth of material in the AGO's file of newspaper and magazine clippings about Goldwin Smith, James Mavor's *My Windows on the Street of the World* (1923), Hector Charlesworth's *Candid Chronicles* (1925), and Elizabeth Wallace's *Goldwin Smith: Victorian Liberal* (1957). In her brilliant evocation of late Victorian Canada, *The Private Capital* (1984), Sandra Gwyn described the Aberdeens' visit to The Grange.

Dennis Reid, chief curator at the AGO, helped me uncover the development of the visual arts in late nineteenth-century Toronto. I relied

on information from his catalogue, *Lucius O'Brien, Visions of Victorian Canada* (1990), J. Russell Harper's *Painting in Canada, A History* (Second Edition, 1977), Katharine A. Jordan's *Sir Edmund Walker, Print Collector* (1975), J. W. L. Forster's *Under the Studio Light* (1928), the AGO's publication *Canadians in Paris 1867–1914* (1979) by David Wistow, and the *Art Gallery of Ontario: Selected Works* (1990). "Toronto Gets a Gallery: the origins and development of the city's permanent, public art museum" by David Kimmel, in *Ontario History Volume LXXXIV*, no. 3 (September 1992), was extremely useful.

Finally, I am very grateful to Dr. Roger Hall from the University of Western Ontario for his historical rigour; The Grange curatorial assistant Jennifer Rieger, who was a fount of information and quiet support; Avril Stringer, chair of The Grange Volunteer Committee; and the volunteers themselves, who welcomed me to the house. I would also like to thank Larry Pfaff and Randall Speller in the AGO Library.

HOME TO HOUSE
THE GRANGE 1910 TO TODAY

Jennifer Rieger

In January 1910, shortly before Goldwin Smith died, he received a letter from Edmund Walker, chairman of the council of the fledgling Art Museum of Toronto, outlining its plans for the house. The grounds to the south would be turned into a park, to be named after Smith's wife. The house would remain as is and "would be in part a memorial for all time to come of the occupancy of The Grange by [the Smiths]."

The park materialized, although it was named for The Grange and not for Harriette Boulton Smith. But it would take another sixty years before the second promise could be realized. In the interim, The Grange would serve as exhibition, studio and office space for the fledgling art museum, as well as lodgings, a library and even a tearoom. Far from being a static memorial to the Smiths, The Grange was in a state of near-constant evolution.

First, the house needed to be wired for electricity (at a cost of $200) to bring it into the twentieth century. An apartment was built out of rooms in the west wing to accommodate a resident caretaker. The best known was William Downard, who lived in The Grange with his wife and family for nearly thirty years. The Lodge at the top of John Street, for years home to the butler Mr. Chin and his family, was in poor shape and was eventually torn down, as were the servants' cottages to the north of the house. The large room on the east of the building was converted to studio space by the Ontario School of Art and Industrial Design, which rented it until 1924.

By June of 1913, The Grange was ready to open to the public. Lieutenant Governor Sir John Gibson, Mayor Horatio Hocken and Sir

Edmund Osler officially opened the house and its first exhibition of works from Harriette and Goldwin Smith's collection, which they had also bequeathed to the Art Museum. Five hundred and fifty visitors attended. *The Globe* reported the next day that the opening was "the first step in the development of the plans of The Toronto Art Museum [sic] and should mark the beginning of a new era." Well-attended exhibitions were held in The Grange each year, and continued even after the north gallery wing was opened in 1918.

The opening of the 1918 gallery, and of the 1926 wing, meant more changes for The Grange. Several rooms were converted into offices for the small, but growing, gallery staff. The library, originally built and occupied by Goldwin Smith, was becoming a significant fine arts library under the direction of Sybille Pantazzi. The drawing room and breakfast parlour became a public tearoom where tea was served between 3:00 pm and 5:30 pm. During World War II, the Church Friendship League also served tea there to members of the armed forces. In later years, the Junior Women's Committee held fund-raising lunches once a month, much to the consternation of the librarian, who objected to salads being made in the library hallway.

In 1932, the AGT newsletter, the *Bulletin*, went out of its way to praise "the old-world charm of The Grange." That charm would have a new protector in Martin Baldwin, an architect who became director in 1933. He instituted a policy that no structural alterations were to be made: no nails or screws were to be inserted into any of the woodwork, file cabinets and heavy bureaus were moved next to exterior walls, and drawings were made of the original mouldings. Despite the increasing demand for office space on the part of the art gallery, carving up The Grange was not the answer. The annual report of 1937 stated emphatically that: "The Grange, besides being inconvenient for office use should, we think, be returned as nearly as possible to its original state as an example of what a fine house of the 1830s in Toronto looked like."

Yet there were also advantages to working in the cramped surroundings of The Grange. On Wednesday nights, admission to the gallery was free and the drawing room served supper — tuna casserole and salad for fifty cents. Staff sherry parties were held regularly and staff frequently

30. Sunday afternoon tea in the drawing room of The Grange, 1943.

resorted to using the offices as dressing rooms for formal evening events and openings. In many ways, The Grange was home to the AGO family.

By the late 1960s, the long-awaited expansion of the gallery was underway. At last the staff would have proper offices in a new office wing and The Grange was poised to assume a new role. Public enthusiasm for preservation of heritage buildings was in the air. In 1967, gallery director William Withrow asked the Women's Committee to fund a feasibility study for the restoration of The Grange.

Since the structure of the building was sound, the Women's Committee, under the leadership of Elise Meltzer and after her death Mary Alice Stuart, agreed to take on the restoration project, for which they raised $650,000. Peter Stokes was the restoration architect, Jeanne Minhinnick the interior consultant and Margaret Machell, a senior AGO staff member was given the title "Keeper of The Grange" as curator. The aim of the restoration was to re-create a gentleman's home as it would have appeared in Upper Canada in 1835.

The project relied on a blend of guesswork and research. As much as possible, original building techniques, tools and building materials were used. Little of the original furniture remained: from the Boulton era there were two sideboards with family crests and several wardrobes. No photographs, engravings, inventories, diaries or other concrete evidence of the rooms or their contents existed from this time period. The additions of 1840 and 1885 were to be ignored as were the photos of the late Victorian era. The original building was Georgian in style and that became the focal point.

Although the restoration was ultimately a kind of fiction — a work of installation art in its own right — Minhinnick was adamant that The Grange not appear falsely extravagant: it must accurately reflect the limited range of goods and the colonial craftsmanship of early nineteenth century Upper Canada. Most of the furniture therefore dates from 1820 to 1840. Minhinnick also wanted the house to look as if the family had just stepped out. Hence the half-eaten meal in the dining room, the supplies in the pantry, the open books. There were other practical considerations. The Grange was conscripted as an entertainment venue for the gallery by night, so it required sturdy carpets and electric lighting. Some

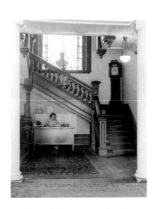

31. Gerry Barton seated at the reception and switchboard area below the stairs, July 1965.

vestiges of the office years remain, such as the director's office at the top of the main stairs, the library restored to Victorian splendour, and the catering kitchen.

In 1970, The Grange was declared a national historic site. Three years later, in 1973, it opened with paid staff and organized programmes. In 1980, faced with government cut backs to the arts, the Board made the difficult decision to let the staff go, and the Gallery was ready to close The Grange. The Volunteer Committee stepped in and arranged to take over the managing, staffing and operating costs until 1996, when The Grange became part of the Canadian Department. Volunteers continue to play an active role as interpreters and caretakers of the collection. After decades of uncertainty, the old home is now secure in its place as a historic house.

House Guests: Contemporary Artists in the Grange

An exhibition on the occasion of the Art Gallery of Ontario's centenary: September 15, 2001 – January 27, 2002.

Generously supported by Carol and David Appel, Jerry and Joan Lozinski.

Artists' texts edited by Gillian MacKay from interviews and written statements.

Installation photography by Steven Evans.

HOUSE GUESTS

CHRISTY THOMPSON

ELIZABETH LeMOINE

ROBERT FONES

ELAINE REICHEK

LUIS JACOB

REBECCA BELMORE

JOSIAH McELHENY

HOUSE GUESTS
CONTEMPORARY ARTISTS IN THE GRANGE

Jessica Bradley

Contemporary artists in The Grange? A collision of opposites, surely? Or an unnecessary disruption of a tamed and appealingly sedate past by the unruly present?

Who are these new "house guests?" What is their art — sometimes hardly visible — and why have they been invited?

The Grange has long beckoned to the curators of contemporary art as a site for a project, its quiet charms seeming to offer artists a unique stage for thoughtful invention. Today both artists and curators welcome opportunities to re-examine entrenched premises about the classification of art objects and the historical truths museums traditionally seek to create for their audiences. With the arrival of the AGO's centenary and an invitation from The Grange curator Jenny Rieger to collaborate on a contemporary project in this historic house, *House Guests* was an exhibition whose time had come.

Only thirty years ago the historical consultant Jeanne Minhinnick contemplated the empty rooms of The Grange and devised appropriate furnishings and accoutrements for its restoration to a circa 1835 gentleman's family home. In a reversal of that process, my colleagues and I considered what appear today to be the inviolable and staid period rooms of The Grange. We then drew up a list of guest artists who might appreciate the opportunity for a metaphorical stay in them.

Which artists would find an affinity with the objects and atmosphere of the house or, alternatively, which ones would incisively deconstruct appearances — like ungrateful house guests overheard criticizing the predictable decor or appraising the table ware? Never attempt to second-guess

an artist. The seven artists who responded to our invitation were chosen for their convergent interests in archives and collections, social and colonial history, domestic architecture and craftsmanship, and anthropology. They received the invitation with varying degrees of enthusiasm, curiosity and amusement, but always with a single-minded seriousness.

House guests usually bring laughter and companionship, and at times, a cool reappraisal of friendships. They may leave their belongings behind or disturb ours. Some bring a vintage wine or flowers too long absent from the mantle. Others eat our food indiscriminately, emptying the refrigerator, and expect a schedule of entertainment that makes our own home feel like the hotel from hell.

What will these current guests in The Grange leave behind for future guests? Are their contemporary interventions merely those of impudent interlopers in a tranquil and thoughtfully reconstructed scene, which has quite enough to say about itself? The AGO welcomed Rebecca Belmore, Robert Fones, Luis Jacob, Elizabeth LeMoine, Josiah McElheny, Elaine Reichek and Christy Thompson with the belief that there is more to be said and seen in The Grange than meets the eye. The journey of discovery promised to be a memorable one.

What does it mean for an artist to "intervene" in a site? The word intervention implies a disruption of the status quo, which depending on your point of view, could be pointlessly annoying, or enlivening and enlightening. Since the 1960s, artists have moved far beyond the confines of conventional exhibition spaces. Their reasons are myriad: the wish to elude curatorial and market control, the proliferation of innovative and ephemeral art forms such as performance and conceptual art (themselves symptoms of resistance to the conventions of display and commodity status), the desire to engage directly with the public and with the fabric of everyday life. Since the 1970s, artists have realized extraordinary projects in sites as diverse as deserts, villas, abandoned factories, prisons and hospitals, not to mention entire cities (like Münster, Germany where every ten years since 1977 an international exhibition of sculpture is mounted throughout the city). And for the *Chambres d'Amis*

exhibition in Ghent, Belgium in 1986, private citizens turned over their homes to enable artists to create installations in domestic spaces.

As the twentieth century drew to a close, another impulse was afoot in installations that plumbed the meaning and shape of history itself. By then the traditional premises of Western art history as a culturally determined system of representation had already been thoroughly questioned and analyzed through the filter of other disciplines, including psychoanalysis, literary theory and sociology. Historical, social and linguistic portrayals of time, identity, power and gender were challenged and found wanting. Artists took part in the larger process of critiquing the making of historical meaning. The exhibition *Places with a Past*, held in several sites throughout historic Charleston, South Carolina for the 1991 Spoleto Festival, was a landmark in that movement.

A resurgent interest in history — how it is told, who tells it and what contingencies shape the telling — characterizes a variety of artistic endeavours today. This interest does not arise from a nostalgic desire to return to origins. Rather it centres on attentiveness to memory and remembrance, in a culture increasingly marked by the economics of built-in obsolescence. More importantly, it signals a continuing need to unsettle and reinterpret histories that, in the shifting of old hierarchies to make room for new voices, have often come to light as half-truths.

32. A Grange volunteer navigating *The Sounds of The Grange*, a series of audio responses to The Grange, created by fourteen youths from Harbord Collegiate Institute and the AGO's Teens Behind the Scenes program.

A century has passed since The Grange was bequeathed to the Art Museum of Toronto as the city's first public art gallery. Today visitors to the Art Gallery of Ontario cross a threshold from the imposing architecture of the modern museum building into the quaint comfort of The Grange. In contrast to the aloof grandeur of the galleries, The Grange seduces the viewer's imagination room by room through the careful orchestration of a domestic narrative. The story takes shape through the ticking of a clock, the afternoon light filtering through muslin draperies, and the faint whiff of wood smoke mingling with that of freshly baked bread from the kitchens below, where the servant bells once roused a flurry of chamber and scullery maids.

In other words, The Grange is still keeping up appearances, though

33. Elaine Reichek making final adjustments to one of her embroidered fire screens in the library.

34. Rebecca Belmore completing the bed covering for *Wild*.

in a way that is really not so different from the familiar etiquette and order of a modern museum. After all, the whole house is now an installation, a fabrication based on a collection of artifacts brought together to form a story with several points of entry and more than one plot. Those plots, and the reinterpretation of the intended narrative, are at the heart of the works made for The Grange by these artists.

In her essay for this book, Charlotte Gray gives a vivid picture of life in The Grange, drawing out the indispensable roles of the two mistresses of the household, Sarah Anne Boulton and Harriette Boulton Smith. Yet the historical documents of that time are all but silent on the subject of these two remarkable women. History, unsurprisingly, has focussed on the public lives of the men of the house. With deft wit and hands, Elaine Reichek gives voice to a private, female history, ironically rewriting it on linen with needle and thread. Her five embroidered fire screens blend with the existing decor of the library, like ladies who, knowing their place in the social order, maintain the appearance of attractiveness and discretion even while voicing subversive opinions. Entitled *As She Likes It*, Reichek's ensemble evokes a female fireside chat where the repartee, though of Shakespeare's invention, brings to life a timeless battle of the sexes, which was no doubt familiar to the former ladies of the household.

Rebecca Belmore has also chosen to intervene in a room in which her very presence would have been an affront. In her work *Wild*, which includes several performances, she takes possession of "the best bedroom." Like Reichek's, her work refers to an invisible history, in this case that of the First Nations tribes who were the earliest inhabitants of the land on which The Grange stands. Through her physical occupancy of the four-poster bed, now re-covered in hair and fur, Belmore plays the role of an unexpected and historically unwelcome guest in the most intimate room in the house. Through this work she enacts a layered redressing of history while fulfilling the fantasy of finding a comfortable, even luxurious, place to stay in a hostile world — a world that saw her ancestors as potential aggressors to be feared.

Ancestry, property and succession are central to the story of The Grange's evolution into today's Art Gallery of Ontario. In *Childless*

35. Robert Fones installing *Childless*.

36. Christy Thompson arranging the elements of *camper*.

Robert Fones examines this heritage as a story of inheritance and loss, poignantly symbolized by a nineteenth-century doll recently unearthed by friends during excavations around the foundations of a Queen Street restaurant. Fones's panoramic photographic work depicting a section of Lake Ontario shoreline engages the viewer in an enigmatic psychological scenario that heightens our experience of the present. He does this by fusing images from different historical periods into one seamless reality. Contemporary portraits of two young women appear to watch the passing schooner *Speedy*, which sank during a storm in 1804. On board was doomed passenger Robert Gray, who had owned the land that D'Arcy Boulton was then able to acquire as the site for The Grange.

By implying the presence of the same lake not so far from The Grange today, and perhaps at one time visible from top floor windows, *Childless* both represents reality and is a fabrication that transports the viewer to another time and place. Now the sweep of the lakeshore is most commonly glimpsed in downtown Toronto while speeding along the Gardiner Expressway or surveyed from the vantage point of the CN Tower. In this regard, *Childless* becomes a fitting metaphor for the failure inherent in attempts to create historical veracity in sites such as The Grange: all histories are partial reconstructed narratives with blind spots, both willful and inadvertent. After all, our view of the past is framed from where we stand today.

Christy Thompson brings to her work, entitled *camper*, childhood memories of visits to The Grange, where the shadowy mysteries of the old-fashioned kitchens and scullery held a particular fascination for her. Life in this part of the house was largely female. Though devoid of the genteel pleasures of the upper floors, there must have been laughter and companionship here as well as hard work. While the eerily flickering light in Thompson's bottles reminds us of the warmth and life that was once downstairs, it also responds to the heat and light of the coals (still kept burning today by The Grange volunteers who make bread) in the oven at the other end of the house. Like Robert Fones, Thompson pays attention to the marginal and overlooked. The Grange's dim cramped scullery can be easily missed by visitors, and a summary glance reveals objects we know well. In fact, bottles have changed little in appearance

since the early nineteenth century. Thompson's bottles shrewdly masquerade as their neighbours on the same shelf, causing a double-take effect when the flames within them are noticed.

Elizabeth LeMoine lavishes similar attention on humble objects; however her sculptures are tiny and their recent creation unambiguous. These miniature objects arise from memories of adolescent years spent in Scarborough, when Toronto beckoned to her fervent desire for the activity and adult sophistication envisioned from the perspective of a young woman yearning to escape the suburbs. Today those visions of Toronto have been modified by time and experience, including the past decade during which she has lived in London, England.

LeMoine's sculptures are radically shrunken but familiar modern objects displayed in such a way that we apprehend them by chance, like apparitions. Paradoxically, their presence brings the fabricated historical surroundings of The Grange interiors into sharper focus. LeMoine asks, "How faithful is memory?" Her sculptures are conceived in admittedly futile attempts to make memory concrete. Their uncanny familiarity lingers the way a recollection or a dream can impinge upon incongruous circumstances and unrelated thoughts, like a nagging fragment of something larger and more important that cannot be reconstructed.

While Josiah McElheny's work, entitled *Four Mirrors, a Painting, and a Fiction by Jorge Luis Borges*, incorporates the ancient art of mirror making, Luis Jacob's *In All Directions* is constructed using the high-tech materials of contemporary lighting systems. In very different ways, both artists confront history through the ephemeral qualities of luminosity and reflection. Their works seem to ask: If modernity floats upon the surface of the dark pool of the past (rather like Narcissus's ideal reflection of himself), or is stacked precariously upon the shifting junk pile of history, how are we to see ourselves? Can a considered backward glance really assist us in foreseeing the future toward which we rush inexorably?

Installed in the entrance hall, McElheny's mirrors invite a fleeting and subtly unnerving glimpse of oneself entering or exiting The Grange. The artist has included in his installation The Grange's 1847 marriage portrait of Harriette Boulton veiled in lace by George Theodore Berthon; the veil would have been lifted at the wedding ceremony, symbolically

37. Elizabeth LeMoine adjusting *My Dad as Mr. Peanut*.

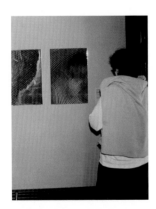

38. A visitor contemplating Josiah McElheny's *Four Mirrors, a Painting, and a Fiction by Jorge Luis Borges*.

marking her social transition from daughter to wife. The decorative overlay on McElheny's mirrors becomes a veil that alters our reflected image and suggests, perhaps, that the features of our identity and social status are less easily removed than Harriette's lace. As the interiors of The Grange approximate a portrait of its former inhabitants, in his installation McElheny uses the layered material history of mirrors and incorporates a haunting text by Jorge Luis Borges about memory, bringing the past to meet the present in our own image.

Luis Jacob's *In All Directions* traces the movement of a figure, perhaps a former guest. Too rambunctious for the elegant surroundings of the music room, or stifled by them, the figure appears to rush toward the outer wall of the house and the expanse of the park beyond. At once a ghostly presence and an incongruous contemporary structure that bisects the room, this evocation of movement through light is filled with urgency and life. Occupying the music room, a space designed to welcome large groups of guests for parties and entertainment, Jacob's luminous work cuts forcefully through time and space. These, too, are the aspects of our existence that have been radically altered in this century, most markedly in the rise of urban centres. The resulting transformation of the world we live in has been in part beneficial, enhancing communication and convenience, for example. Yet the mechanisms that increasingly collapse time and space have also had calamitous social and economic repercussions. Weaving the past and the present with strands of light, Jacob makes a poetic, even humorous statement about our will toward progress. And perhaps he also asks: What is this brighter future based upon?

Invited as guests to The Grange, these artists have become hosts by offering us their work to contemplate. We are invited to share their affectionate irreverence and their pleasures of discovery. The objects they have made will disappear from The Grange at the end of the exhibition, but they will remain in our memory. Their work has made it possible for us to see the familiar anew.

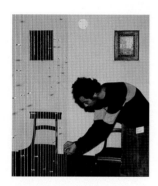

37. Luis Jacob installing *In All Directions* in the music room.

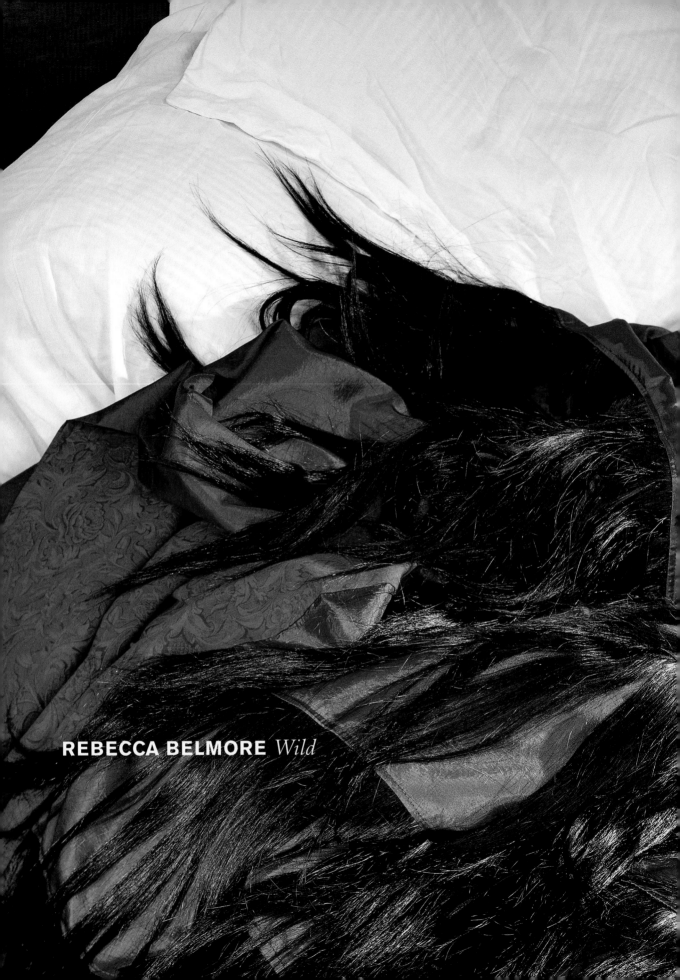

REBECCA BELMORE *Wild*

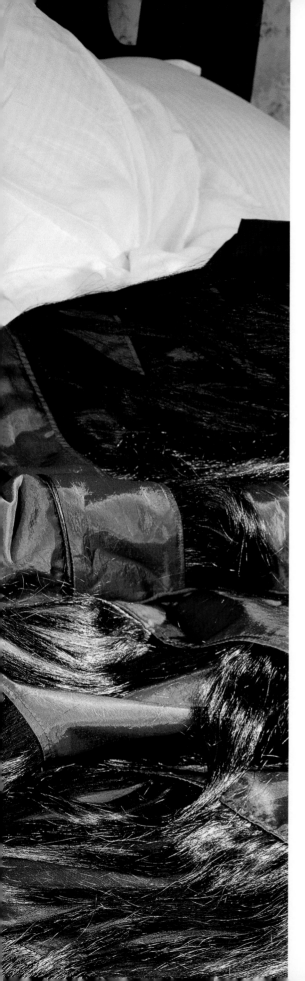

I wish to rest my weary body in the master's bed. The bed
has an autonomous quality that I find extremely attractive.
The bed is a fortress. The four posts clearly marking its terri-
tory. Its canopy offering protection from the powers that live
in the sky. It has become my shelter.

I have re-dressed this bed. The bedcover is made of
long black hair, the canopy is trimmed with fur. To lie in this
historic bed covered in a mass of hair is evocative of a time
when the newcomers to this land viewed us as wild. The
decorative fur detail of the canopy refers to the taking and
taming of this "wilderness." My black hair is a celebration
of survival.

By occupying a place as personal as this bed I am making
a connection between myself and the history of The Grange.
It is a way of asking, "Where is my history?" This placement
of myself in the most private part of this house — an Indian
woman in the white man's historic bed — is for me a vulnera-
ble position and the warmth of my skin unsettling to the care-
ful composure of the household.

I cannot even begin to imagine being an Indian woman liv-
ing in another time. The reality of constantly having to assert
oneself in a world that has only a vague memory of us is tire-
some. My persona reaches back in time to find someone not
unlike myself. She claims this foreign place for all my mothers
before me.

Looking around this room, which is heavy with posses-
sions from the past, I imagine the weightlessness of the
houses of my ancestors. Then, who would I have been? I most
certainly would not have entered this house. Now, as a con-
temporary artist, I have been invited.

My presence in the stillness of this room surrounded by
a sea of black hair suggests the natural process of time on
our bodies and ultimately death itself. The objects kept here
in this vacant house are meant to preserve a past. Beyond
this house, somewhere on the land is my history. This is
comforting.

And on this bed I rest and I dream.

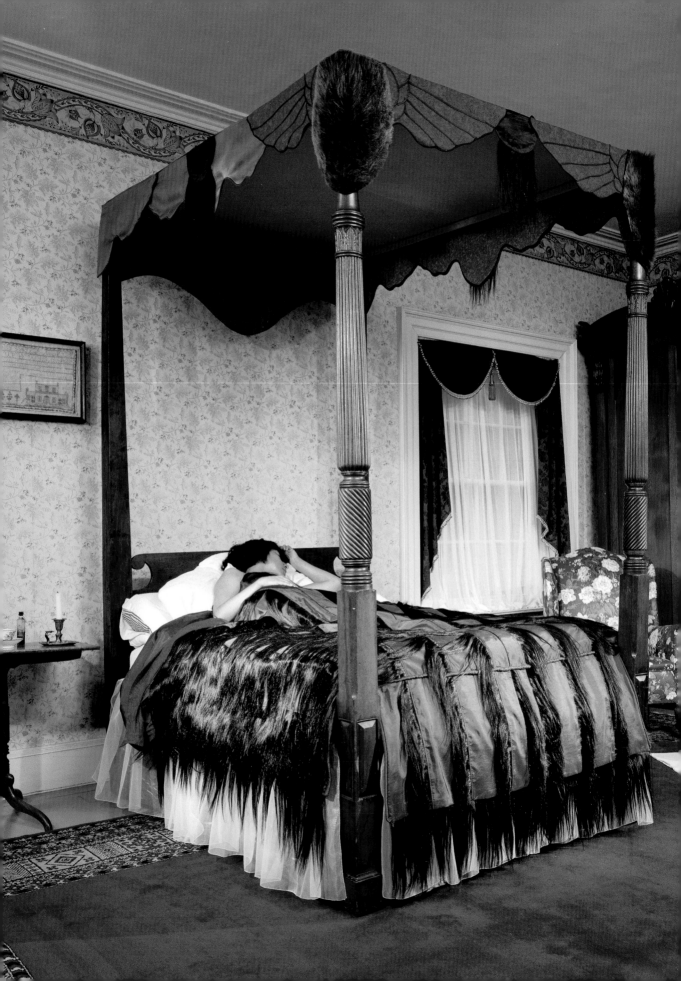

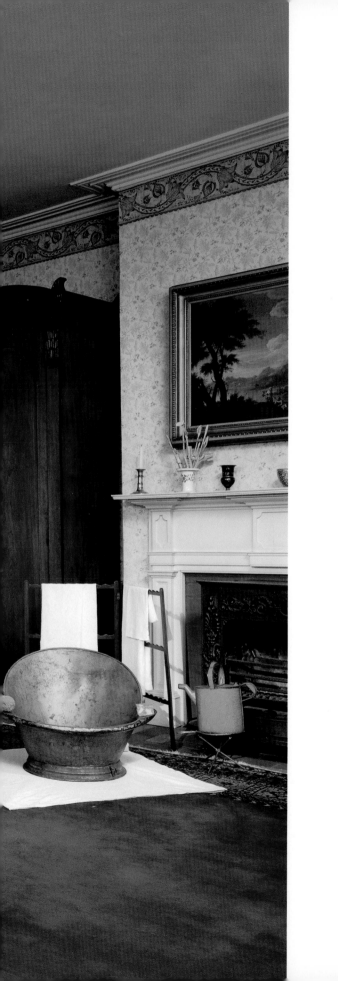

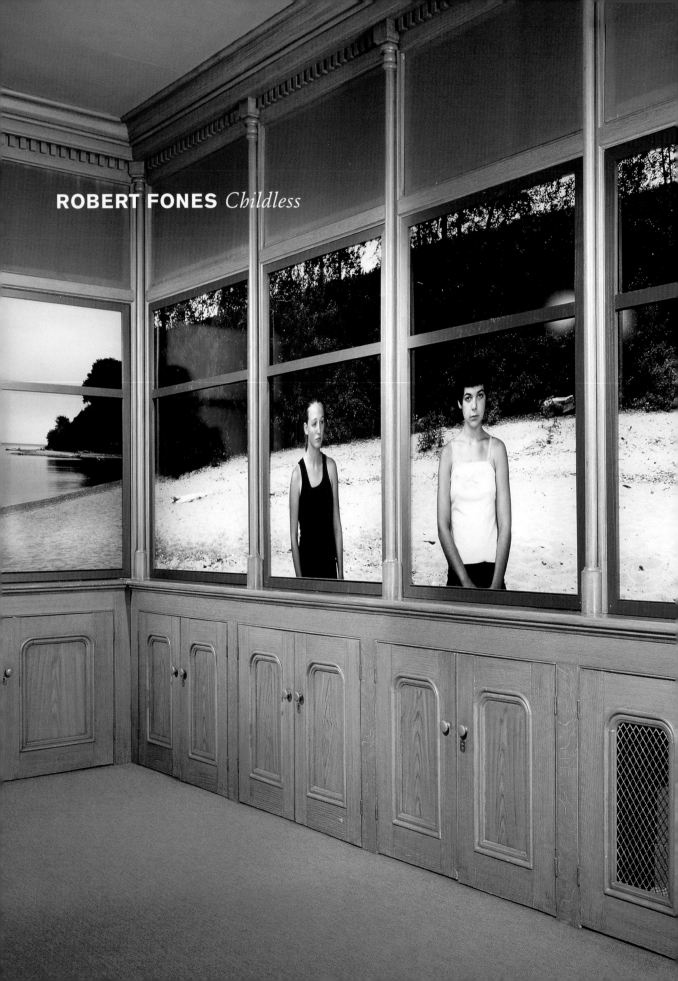

ROBERT FONES *Childless*

The title of my work, *Childless*, refers to the fact that William and Harriette Boulton had no children. It deals with the idea of generation, both human in the sense of a continuing genetic line and historic in the sense of time and space always being replaced with more recent events.

I was intrigued by the fact that The Grange had once been a family home — that children played and grew up here. My work is installed in the room that was William Henry Boulton's office when he was mayor of Toronto. There is no furniture in it now, nothing to suggest its original function. It's a horrible room, really. It's suffocating. I don't know why he chose to work in it.

I found it hard to relate to William Henry Boulton — he seems not to have been a particularly enlightened or interesting man. Yet at some point, sitting in this office, he must have realized that his estate, which had been built by his father, would not pass on to the next generation. Thinking of that gave me something to work with.

After William died, Harriette remarried but again had no children. There were no heirs and she bequeathed the house as an art gallery. I suppose leaving the building was in a way a continuation of the dynasty, but not in the form that things are usually handed down. So, it was an incredible gesture of altruism.

What interested me about this room was the opportunity to create a photographic installation that would extend the space out into the landscape. The walls are lined with glass display cases, and I have removed the historical photographs and artifacts that are normally shown there. Directly behind the glass, I have installed a connected series of large photographs of water, waves and shoreline. The horizon line is constant so that what you experience is a panorama seen through window-like openings. It is as if you are standing on the shore looking out to Lake Ontario.

Formally, I wanted as much as possible to destroy that notion of discrete display cabinets that try to engage you in history, but I think actually alienate you from history. I watched the video of the restoration of The Grange and I far preferred the building as a stripped-down derelict structure, rather than as an artificially restored simulation. By creating a panoramic space that goes beyond the room I am hoping to situate the viewer in a larger imaginative history.

That idea I stole from early Roman painters who often painted rooms with architectural or garden details that pictorially extended the space. There is a house called Villa of the Mysteries just outside Pompeii, which was owned by a woman who was a member of a cult. One room in the villa

was used for ceremonial rites. It has a red background and various aspects of cult rituals are depicted on the wall — one woman is being lashed with a whip, another is holding a bowl of water. The figures look at each other, and one of them looks at the viewer as you walk into the room.

I was really struck by that. It is not the same as making eye contact with a figure in an easel painting. These figures are almost life-size and they occupy the same space as you do. You feel put on the spot and psychologically engaged. The meaning of the events has been lost; yet there is something basically human here that hasn't changed much in over a thousand years.

As you enter the installation at The Grange you see within the panorama two young women in their late teens. I think of these two girls as looking through time to the distant past and to the future; both are potential child bearers who might be considering their own motherhood. One young woman's eyes greet you as you enter.

The other girl is positioned in such a way that their gazes actually cross. I like that idea of crossed gazes. She is looking at an enlarged photographic image of a ceramic doll. It is a tiny, beautiful, exquisitely detailed, Victorian child's toy that my friends found when they were digging up their yard behind the Vienna Bakery. I knew as soon as I saw it that I wanted to use it in a work of art.

On the same wall is an image of a small ship. This represents the *Speedy*, a schooner that left York in October, 1804 and sank. All eleven passengers and crew drowned, including Robert Gray, who was solicitor general of Upper Canada. Also on board were a native man who had been charged with murder (the boat was taking him to trial at the courthouse in Newcastle, Ontario), and two nameless children. Robert Gray had owned the land that The Grange now sits on, and it was his death that made it possible for D'Arcy Boulton to acquire the property.

I don't want the installation to be romantic or sentimental in the sense that you are only aware of something that happened in history. Nor do I want a closed narrative. I would rather leave things ambiguous enough that viewers could construct stories of their own. Simply trying to do that from the clues provided could be entertaining and engaging on its own without knowing anything more about the history of The Grange and its occupants. I also hope the work will have sufficient resonance that it will encourage people to reflect on the narrative of their own lives. It is rare in life that we have that opportunity.

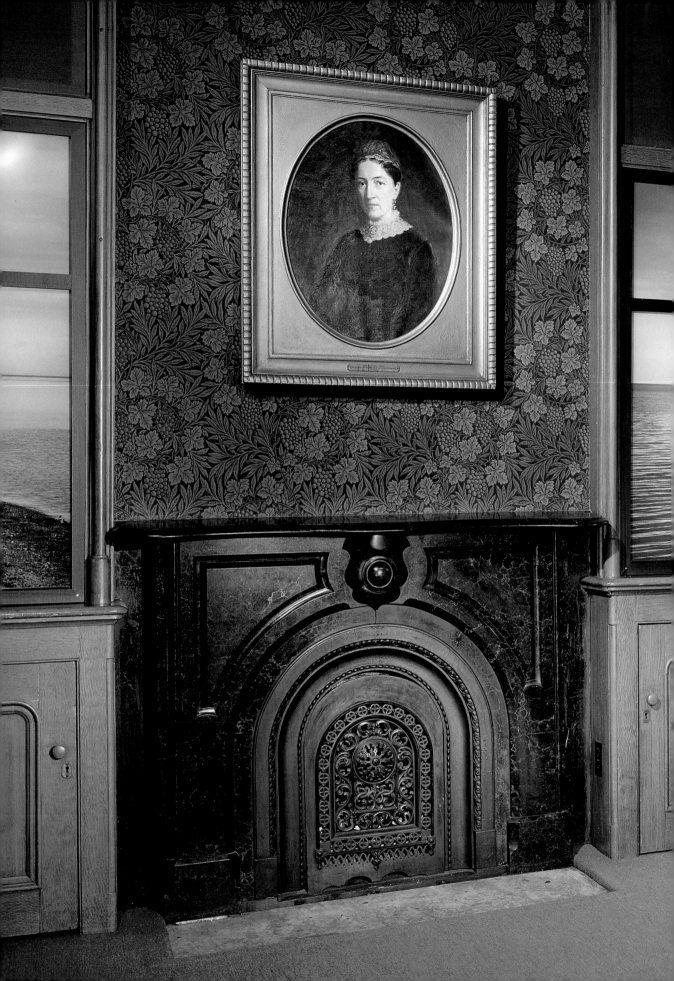

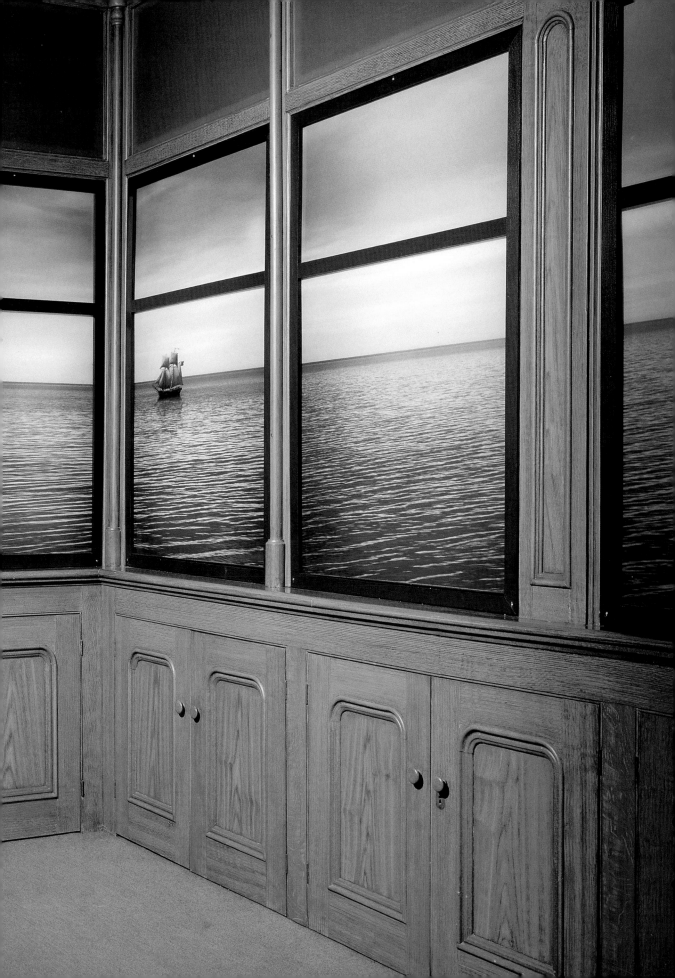

LUIS JACOB *In All Directions*

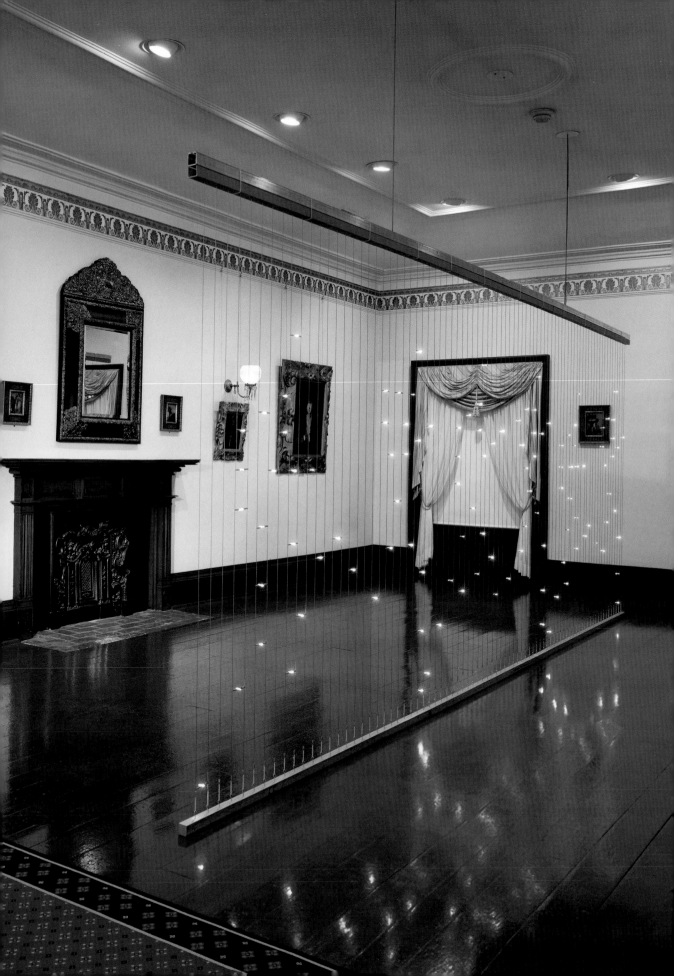

The Grange was the private residence of the Boultons, one of the most prominent families in Toronto's early history. As a site of economic and political power, the residence had a strong public role as well, being a place where members of the nineteenth-century ruling class would meet, socialize and form partnerships.

This public role continues to this day, but in a significantly transformed manner. Whereas The Grange was initially public in the sense that its occupants and guests exerted power of wide-ranging effects, the house today is public by virtue of its designation as a historic site, and its placement as annex to the Art Gallery of Ontario.

It may indeed be more accurate to view the Gallery itself as an annex to The Grange — as the Gallery is linked architecturally and ideologically to the house from which it originated. These roots are nourished and perpetuated by the Gallery through its donated collection and sponsored programming. Through its collection the Gallery becomes the public repository of the collecting tastes of wealthy individuals; through its programming the Gallery realizes the publicity requirements of powerful corporations.

The Art Gallery of Ontario connects the holders of social wealth and power to an audience that is both the Gallery's philanthropic beneficiary and its means of support. This is one way in which the Gallery fulfills its public role today. It is public also in another way — as its curators, artists and audience present their own various points of view. One can consider as the very definition of the Art Gallery of Ontario, its role as a site where these often competing manners of "being public" are engaged in struggle with one another.

During *House Guests*, contemporary artists are invited to commemorate and interpret the Gallery's roots at The Grange, and the Gallery audience is invited to experience current artistic practice in the context of this historic house.

As a guest at a house — in general, or in this instance — it is your presence that is being requested. A "good guest" is one that recognizes and respects the nature of the place he or she is being invited to.

In a famous passage, the German-Jewish writer Walter Benjamin described history as an angel being blown backwards by the force of a storm caught in its wings. The angel is caught with such force that it is projected towards a future it cannot see. It can only face the past — and this past is a catastrophe, a pile of wreckage growing skyward.

In my work for *House Guests*, I have chosen to depict this angel from a somewhat lighthearted perspective. In my version, the angel moves forward — not backward — and it is driven by the energy of its own exhilaration. Notably, the angel has lost its wings, but it is precisely this fact that enables it to run of its own volition. It has also lost the fullness of its body; it is now reduced to a set of coordinate points on two axes in space. The storm that assailed it may not be presumed to have ceased, but it is the angel's newly disembodied form that has freed it in some way. Like schoolchildren are imagined to do on the last day of class, this angel rushes towards the future with excited anticipation.

It is bad manners for a guest to run and flee from its host's house. Perhaps the house's walls will prevent the angel's luminous, pixillated body from rushing outside and doing itself harm. For the walls of this house are fleshy. These walls are built by history, they are maintained by history and they are the walls that history will build upon or overcome. That is the nature of their fleshiness. Our angel will perhaps only bump its head on the wall, emerging without harm to itself and without disgrace to its host. Or it will perhaps traverse this wall, emerging into the park outside and the city beyond — this city where more people are servants than either hosts or guests.

In my version, the angel is poised between these two possibilities, umbilically connected by a plug to the unseen electrical system of The Grange.

— Artist's statement accompanying installation

Interview excerpt

"In my initial thoughts for this exhibition, I had wanted to propose a project in the servants' area in the basement, to highlight what I think of as the engine of the house. But, strangely enough, I finally decided to work in the most splendid room of all — the music room — in order to address the same issues. The music room was a highly public room in which social events, gatherings and political meetings were held. The house's splendour is in one place but the source of the splendour is behind view. Power manifests its radiance elsewhere than at its source. In an inequitable society such as ours that is always the case, and that is always the way in which power will work.

The final installation is a hanging light fixture on a track system, which starts at the centre of the music room and ends at its south wall. The lights describe a figure running through the room, depicted in six stages of running. The sixth figure is situated at the last possible moment before it would hit the wall. There is something spectral about the figure, which suggests the freedom to pass through walls. At the same time, the figure is embodied like the audience: it is life-size, and its proportions are anatomically correct.

The fantasy of transcendence is definitely a part of this piece. It could be a transcendence of history, looked at as an oppressive weight; of social hierarchies and the class system; of anything that is holding you back. I wanted very much to harbour hope."

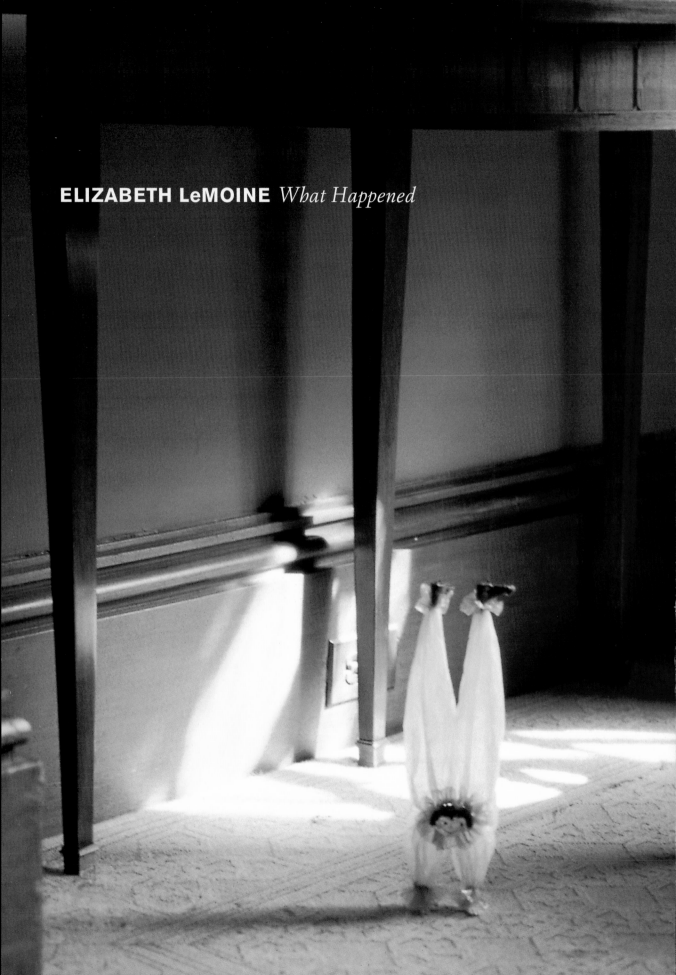

ELIZABETH LeMOINE *What Happened*

My work is about memory and the places where personal and collective history intersect. For *House Guests* I have "reconstituted" some memories, which I hope will be shared on some level by visitors to the exhibition. Most refer to Toronto particularly, or Canada generally, between the mid 1950s and the early 70s. In the time frame of The Grange, these reconstituted memories represent the future, but for contemporary visitors they are reminders of the past. I hope that in this historic setting, these objects will stimulate viewers' thoughts on the complexity of the past and its representation, and will provide the pleasure of recollection, the surprise of discovery and the humour of incongruity.

Rather than being confined to a single room, my small sculptures are scattered throughout several rooms and passageways. They aren't all displayed in the same way: some are suspended and others sit on a surface. There are no spotlights or signposts; I want them to catch you unawares, as nearly forgotten memories often do.

When an object is small you have to get up close and give it a certain kind of attention. For a moment the rest of the world disappears. Whereas experiencing a huge painting is engulfing, becoming absorbed with small objects is voluntary. The negotiation between the object and the viewer is

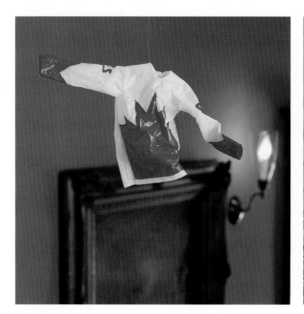

different. I think this space stimulates recollections and memories.

One vivid teenage memory I have is of reading a newspaper interview with Glenn Gould. Like most adolescents, I felt "different", and I recognized a kindred spirit in Mr. Gould. For a time I planned to turn up at his studio and introduce myself. I imagined it would be easy and we would become friends. But I became busy and never got around to it, and that's one of my biggest regrets, because he died not long afterward.

One of the objects I've made for *House Guests* is a Glenn Gould album of three Beethoven piano sonatas. The original album cover shows him walking in a wintry landscape. I made five attempts to draw it from memory before I was satisfied. I remember the landscape as huge and him as very small with his back turned. As I drew, I thought with admiration of the album cover designer, "Wasn't that brave to trust that people would recognize Gould in this tiny figure?" Eventually I asked my dad for a scan of the album cover. It's amazing how far off my memory was, and how psychologically telling! In fact, Gould faces the camera and is compositionally big. I decided to keep the album as I had drawn it. I don't just want to make miniature replicas.

Translating a memory into an object is not always straight-forward. Sometimes the object comes first, eventually coming to represent a time or a feeling. For example, I'd been thinking for a while about those little tree-like coffee mug stands. As ordinary domestic items, they conjure up the 1960s wonderfully. For this project, I put the centennial maple leaf on the mugs. The emblem is strongly evocative of both an era and a big idea about national identity. Combining the maple leaf symbol with this banal, domestic novelty item gives poignancy to both concepts.

The centennial mugs are made from a hobby material, painted with nail polish. The stand is made from a matchstick and toothpicks. I use materials commonly found around the house, which allows me to be spontaneous. (I often use plastic shopping bags, as in my Team Canada jersey.) Humble materials connote insignificance, but working them carefully makes them worthy of notice. Thoughts and memories are fleeting. The objects need to be made with the lightest possible touch.

No doubt most of us have wondered what people from the past would make of the modern world if they suddenly turned up here. I like the idea that perhaps someone looking at my little sculptures considers what would be involved in explaining their significance to Goldwin Smith. The process would be comical and far from straightforward, because you would have to back it up with so much explanation about what had happened to Toronto and the world after Goldwin Smith had gone.

I hope the installation suggests the impossibility of fully communicating the past. Consider how much information would be required just to do justice to your own life story, assuming you even could remember it all and find a way to present it. So, it's not surprising that heritage experiences like The Grange fall short of being "portals" to other times and other lives. The Grange is an important document of Toronto's past — no denying it. However, it's a modern-day construct, built upon various clues and educated guesses. Neither, it can be argued, are our own memories authentic, since they are mediated by various representational conventions as well as by individual subjectivity.

Personal history is the way you sift through all the events of your life to make a story that makes sense. That's what history does. It edits out the things that are inconsistent or illogical. I've found what seems incoherent or not worth including is often worthy of notice. Through these tiny objects that represent both the future and the past at The Grange, I hope viewers' personal memories will be triggered and the complexity of lived experience will be evoked.

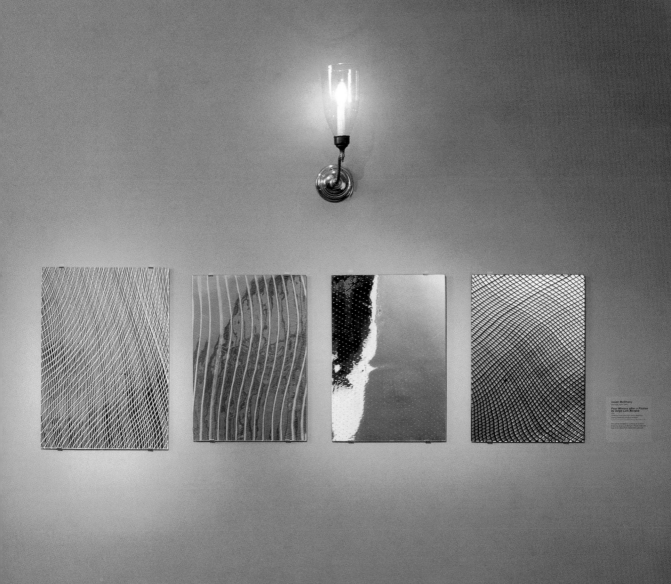

JOSIAH McELHENY

Four Mirrors, a Painting, and a Fiction by Jorge Luis Borges

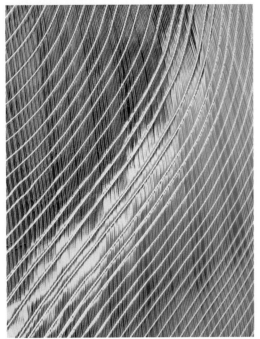

The Draped Mirrors

Islam asserts that on the unappealable day of judgment every perpetrator of the image of a living creature will be raised from the dead with his works, and he will be commanded to bring them to life, and he will fail, and be cast out with them into the fires of punishment. As a child, I felt before large mirrors that same horror of a spectral duplication or multiplication of reality. Their infallible and continuous functioning, their pursuit of my actions, their cosmic pantomime, were uncanny then, whenever it began to grow dark. One of my persistent prayers to God and my guardian angel was that I not dream about mirrors. I know I watched them with misgivings. Sometimes I feared they might begin to deviate from reality; other times I was afraid of seeing there my own face, disfigured by strange calamities. I have learned that this fear is again monstrously abroad in the world. The story is simple indeed, and disagreeable.

Around 1927 I met a sombre girl, first by telephone (for Julia began as a nameless, faceless voice), and, later, on a corner toward evening. She had alarmingly large eyes, straight blue-black hair, and an unbending body. Her grandfather and great-grandfather were *federales*, as mine were *unitarios*, and that ancient discord in our blood was for us a bond, a fuller possession of the fatherland. She lived with her family in a big old run-down house with very high ceilings, in the vapidity and grudges of genteel poverty. Afternoons — some few times in the evening — we went strolling in her neighborhood, Balvanera. We followed the thick wall by the railroad; once we walked along Sarmiento as far as the clearing for the Parque Centenario. There was no love between us, or even pretense of love: I sensed in her an intensity that was altogether foreign to the erotic, and I feared it. It is not uncommon to relate to women, in an urge for intimacy, true or apochryphal [sic] circumstances of one's boyish past. I must have told her once about the mirrors and thus in 1928 I prompted a hallucination that was to flower in 1931. Now, I have just learned that she has lost her mind and that the mirrors in her room are draped because she sees in them my reflection, usurping her own, and she trembles and falls silent and says I am persecuting her by magic.

What bitter slavishness, that of my face, that of one of my former faces. This odious fate reserved for my features must perforce make me odious too, but I no longer care.

— *Jorge Luis Borges*
text included in the installation

Four Mirrors, a Painting, and a Fiction by Jorge Luis Borges consists of a painted portrait from the collection of The Grange, a work of my own, two typical AGO museum labels and a text (reprinted above) by Jorge Luis Borges entitled "The Draped Mirrors". The display occupies the area where the visitor first enters The Grange from the Art Gallery of Ontario. In this space normally stand a couch, a group portrait and a bust.

Walter Benjamin said, famously, that the house is a museum of the self. It follows that The Grange could be said to be about self-portraiture and reflection. The installation that forms my participation in *House Guests* is informed by these simple notions.

The portrait is of Harriette Boulton, the young mistress of The Grange, on her wedding day. Usually it hangs in the drawing room where visitors are unable to examine it closely. Perhaps the most striking aspect of the painting is the care and skill with which Harriette's veil is depicted. The gossamer-thin lines that delineate the cloth are more compellingly rendered than Harriette herself.

The glass mirror panels belong to a larger series of works about the mirror as a specific material object and inspired by descriptions of mirror reflections by Borges. The mirrors are constructed using the original Renaissance flat-glass method, combined with various traditional Renaissance glass patterning that imitates lace, creating a kind of "veiled" mirror. These objects are displayed in conjunction with the Borges's evocative short fiction describing his fear of mirrors.

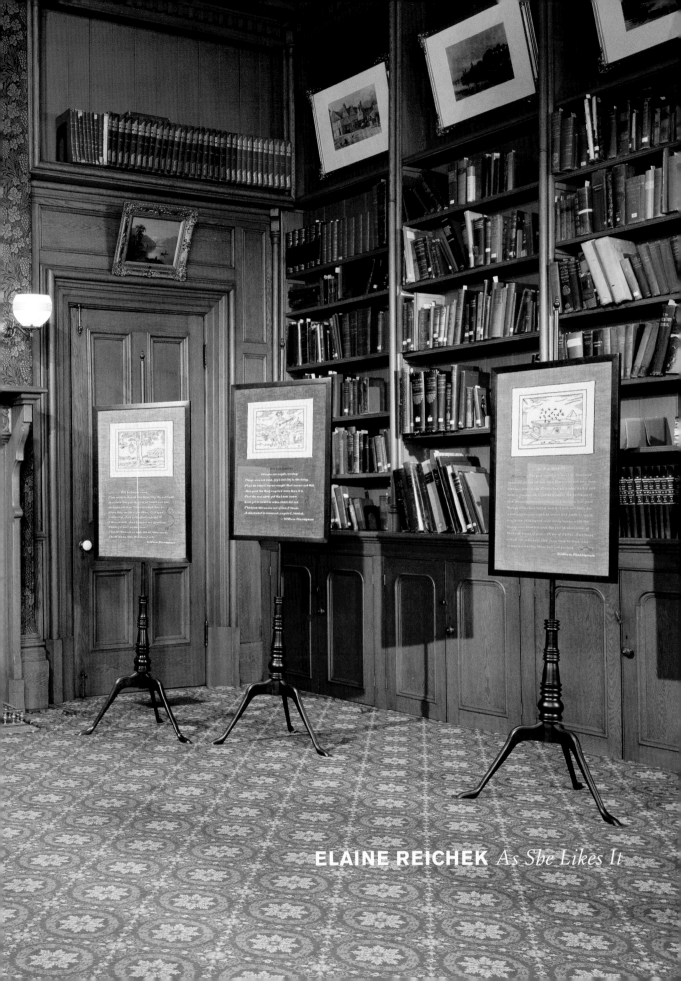

ELAINE REICHEK *As She Likes It*

My contribution to *House Guests* is called *As She Likes It* and is set in the library, a later addition that was commissioned in 1885 by Goldwin Smith, then resident in the house. For an artist who works with text, the library was a logical site to choose. I liked the fact that it is still in active use as a research library and that it wasn't shielded from access the way most of the other rooms are. It was the only room in the house that felt alive to me.

The library is often thought of as a male preserve. Goldwin Smith had come to Toronto after resigning his position on the Board of Directors of Cornell College in Ithaca, New York, partly in protest of the board's decision to admit women students. Yet his occupancy of The Grange depended on a woman — his wife, Harriette — for it derived from his connection by marriage to the Boulton family. Appointing his new library richly, Smith ordered site-appropriate decor, framing the fireplace with Minton ceramic tiles, imported from England and illustrated with scenes from Shakespeare's plays. He also inscribed a manly Latin quotation from Cicero in the mantel, for which the English translation is: "great is the power of truth, which can easily defend itself by its own force."

For *As She Likes It*, I have chosen some Shakespearean quotations of my own, using passages in which women characters express distinctly female points of view on marriage, courtship and other aspects of the relationship between the sexes. The characters talk about how a woman maintains her dignity, her place in the world and her sense of humour in the face of all that she is subjected to. These women are not defeated by the constraints of their situation. They are clever and resourceful.

I have embroidered these quotations on linen — much of my work of the past ten years or so has taken the form of the sampler. The sampler was one of the first instructional devices for women in the United States and Canada. Through embroidery, little girls learned their alphabets and their maxims. Samplers were embodiments of the moral, aesthetic and behavioural codes that defined prevailing notions of femininity.

Yet sewing was also a way for women to demonstrate their power and make a space for themselves. In a sense, the activity of sewing parallels the way in which Shakespeare's heroines use language to carve out their place in the world.

I have combined each text with an image from Shakespeare's time, a visual take on related concerns. The source of these images is *Minerva Britanna*, an illustrated book by a contemporary of Shakespeare's, Henry Peacham. There is a doubling theme in the imagery — two cherries, two birds, two rings — and there is a ribbon-like line that runs throughout. I use images to expand meaning, to point in another direction or to emphasize something in the text. The idea is to add to the quotations, not simply to illustrate them.

Finally, I have made these five embroideries into fire screens — the ornamental screens standing on tripod-like poles with which Victorian women screened their complex-ions from the heat as they sat by the fire. Mr. Smith's virile library now hosts a group of Shakespeare's women conducting a fireside chat.

Quotations from William Shakepeare

A Midsummer Night's Dream (3.2.204–19)
Helena: We, Hermia, like two artificial gods, / Have with our needles created both one flower, / Both on one sampler, sitting on one cushion, / Both warbling of one song, both in one key, / As if our hands, our sides, voices, and minds / Had been incorporate. So we grew together, / Like to a double cherry, seeming parted, / But yet an union in partition, / Two lovely berries moulded on one stem; / So with two seeming bodies, but one heart. / And will you rent our ancient love asunder, / To join with men in scorning your poor friend? / It is not friendly, 'tis not maidenly. / Our sex, as well as I, may chide you for it.

Much Ado about Nothing (2.1.26–34)
Beatrice: Lord, I could not endure a husband with / a beard on his face, I had rather lie in the woollen! /
Leonato: You may light on a husband that hath no beard. /
Beatrice: What should I do with him? Dress him in my / apparel and make him my waiting-gentlewoman? He / that hath a beard is more than a youth, and he that hath no beard is less than a man; and he that / is more than a youth is not for me, and he that is less than a / man, I am not for him.

Othello (4.3.92–102)
Emilia: Let husbands know / Their wives have sense like them; they see, and smell / And have their palates both for sweet and sour, / As husbands have. What is that they do / When they change us for others? Is it sport? / I think it is. And doth affection breed it? / I think it doth. And have not we affections, / Desires for sport, as men have? / Then let them use us well; else let them know, / The ills we do, their ills instruct us so.

Troilus and Cressida (1.2.282–9)
Cressida: Women are angels, wooing: / Things won are done, joy's soul lies in the doing. / That she belov'd knows nought that knows not this: / Men prize the thing ungain'd more than it is. / That she was never yet that ever knew / Love got so sweet as when desire did sue. / Therefore this maxim out of love I teach: / Achievement is command; ungain'd, beseech.

As You Like It (4.1.88–101)
Rosalind: The poor world is / almost six thousand years old, and in all this time there / was not any man died in a love-cause. / Troilus had his brains dash'd out with a / Grecian club, yet he is one of the patterns of love. Leander, he would / have liv'd many a fair year though Hero had turn'd / nun, if it had not been for a hot midsummer night; / he went but forth to wash him in the / Hellespont, and being taken with the cramp was / drown'd; and the foolish chroniclers of that age found / it was Hero of Sestos. But these are all lies: men have / died from time to time, and worms have eaten them, / but not for love.

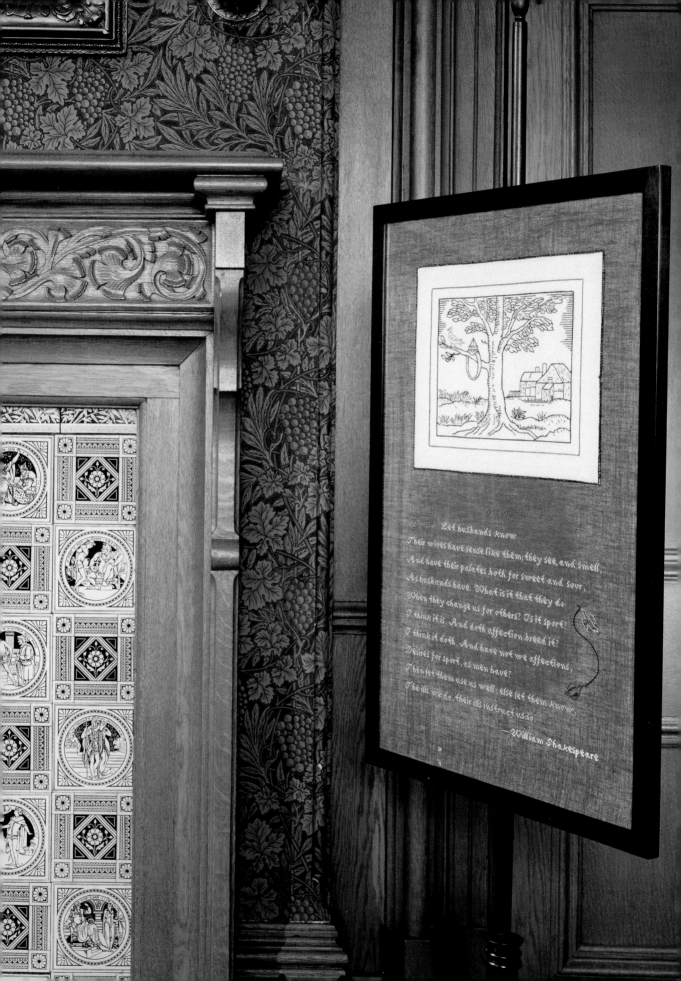

Let husbands know
Their wives have sense like them; they see, and smell,
And have their palates both for sweet and sour,
As husbands have. What is it that they do
When they change us for others? Is it sport?
I think it is. And doth affection breed it?
I think it doth. And have not we affections,
Desires for sport, and frailty, as men have?
Then let them use us well; else let them know,
The ills we do, their ills instruct us so.

— William Shakespeare

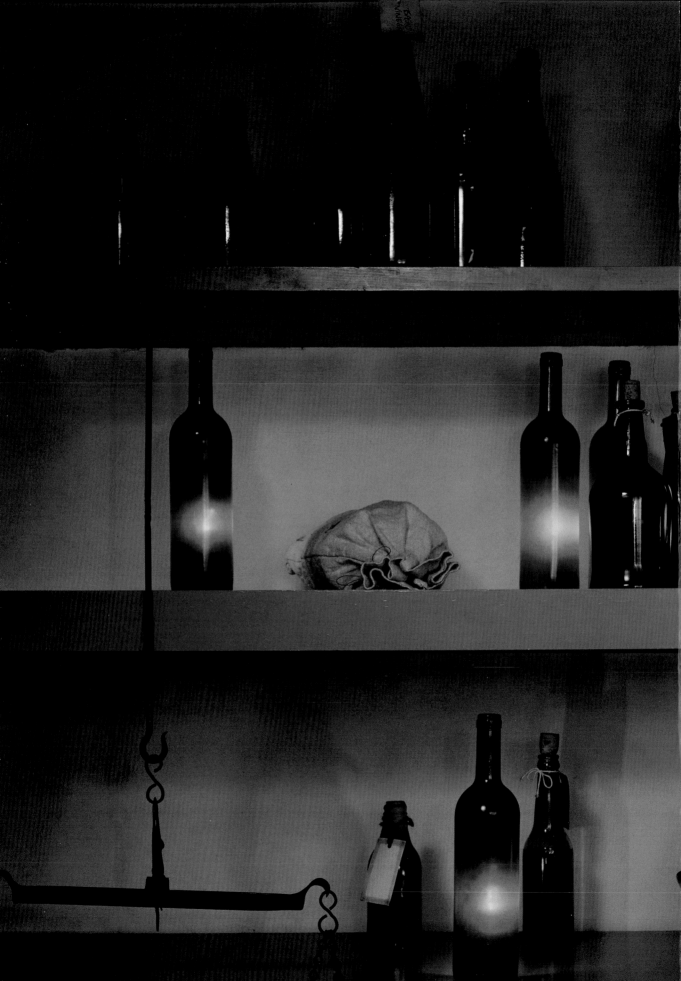

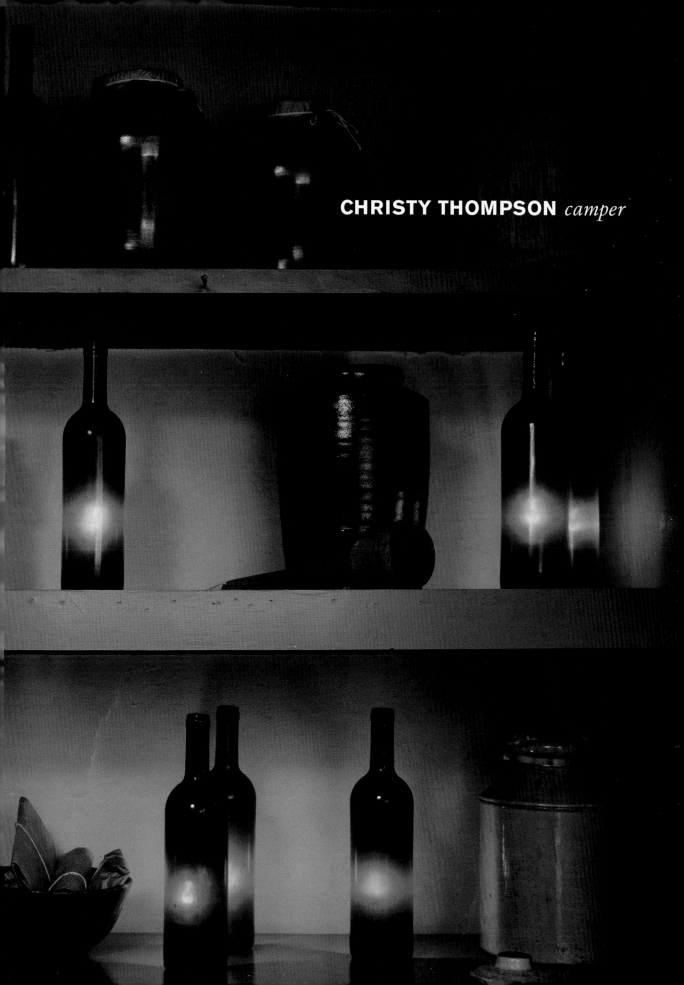

CHRISTY THOMPSON *camper*

When I was in grade school in Toronto we used to visit The Grange all the time, so I have a history with it. I remember really loving the basement, especially the bake-oven with the shortbread cookies. As an artist, I am drawn to the scullery for a number of reasons. In the past, there was a whole subterranean "below-the-stairs" community of servants who probably had their own ideas about what was going on upstairs. Today, this area seems awkwardly silenced, almost as if the servants have just rushed out. I want people to think about that life of work that went on down here. I also like the informality of the downstairs, the fact that the old nicks and bumps are not smoothed over the way they are in the main house.

The Grange represents order and stability now as it did in the past. I want to subtly pull the rug out from under that and question what really did happen. I like the idea of small chaoses existing within the larger order of the house. I feel a bit like I'm sneaking around when I'm here, and I enjoy that sense of quiet infiltration.

The installation takes place in the dry storage area, which would have been used for flour, sugar, salt, oils and vinegars. From here, you can see the bake-oven area, which is very active and usually full of visitors. I would like to reward the person who explores a little further and into this out-of-the-way corner.

camper is a very subtle piece, which mimics the old bottles that normally sit on the shelves. The new bottles are cast in smoky dark resin with bulbs behind them, which are intended to emulate a flame. I imagine the viewer looking in and seeing something flickering. There is a reference to

alchemy in the improbability of light in glass. It is mystic, unfamiliar, difficult to code.

In my work, I like to question what is the artifact and what is the art. Tom Dean's Excerpts from a Description of the Universe, 1984–87 has always been a great influence. He makes credible-looking objects, which are entirely illogical at the same time. It's intriguing when you can't quite articulate what an object is. It's also unnerving, as in the case of the bottles in my installation, where inanimate objects become animate.

I'm hoping through the illogic of that to make people question the logic of everything else. Look at that cone-shaped package of sugar in the corner of the room for example. That's pretty strange. I am asking for a renewal of looking at objects. Art can provide us with an opportunity to observe that which we might otherwise take for granted or overlook.

There is a kind of surrealism in my work, but it is more the surrealism of film-maker David Lynch than of, say, Magritte. I like the combination of terror and humour that you get in Lynch's films. At The Grange, the eerie ambience of an old basement has the potential to create that sort of mood. There is a small window here and I like the idea of someone peering through it at night and seeing these strange lights.

In a sense, the flickering lights in camper represent the past bodies and events that activated these basement areas. The work is essentially a "house guest" that alters the way in which we, as viewers, perceive The Grange and its contents.

The title, camper, was chosen for its very instability. Like a flame, it is constantly changing. These guests are only here temporarily and then they will be moving on.

LIST OF ILLUSTRATIONS

1. View of The Grange from Grange Park, 1999

2. James Bowman (American, 1793–1842) *Portrait of Mrs. D'Arcy Boulton Jr.*, c.1830 Oil on canvas, 87.0 x 76.8 cm. Art Gallery of Ontario, Toronto, bequest of Mabel Cartwright, 1955 (55/37)

3. William Stennett (active in Toronto 1830–1844). *Soup Ladle inscribed with Boulton crest on handle* (detail), c.1832 Silver, 34.5 x 10.5 cm. Art Gallery of Ontario, Toronto, gift of Mrs. N. Beverly Heath, 1972 (G971.90)

4. Henry Bowyer Lane (Canadian, 1817–1878). *The Grange, Home of the Mayor of Toronto*, c.1845. Watercolour on paper, 30.5 x 45.7 cm. Art Gallery of Ontario, Toronto, gift of Mrs. Seawell Emerson, Marblehead, Massachusetts, 1972 (G971.61)

5. John George Howard (Canadian, 1803–90). *Toronto Bay from Brown's Wharf, with the Peninsula and Lighthouse*, 1835 Watercolour on paper, 31.8 x 42.6 cm City of Toronto, Culture Division, Colborne Lodge Collection (1978.41.27)

6. Frederic V. Poole (active late 19th to early 20th century) [after a drawing c.1840 by William Warren Baldwin (1775–1844)] *Spadina House (1836–1866)*, c.1912 Watercolour on paper, 15.5 x 21.5 cm Toronto Reference Library, (T.P.L.), J. Ross Robertson Collection (JRR 715)

7. J. W. L. Forster (Canadian, 1850–1938) *William Lyon Mackenzie*, 1903. Oil on canvas, 167.0 x 113.0 cm. Government of Ontario Art Collection, Archives of Ontario, purchase from the artist, 1903 (MGS 606898)

8. Thomas Young (Canadian, 1810–1860) *View in King Street, (Looking Eastward) City of Toronto Upper Canada*, 1835. Lithograph on India paper (N. Currier), 30.2 x 45.5 cm Toronto Reference Library, (T.P.L.), J. Ross Robertson Collection (JRR 262)

9. William Henry Bartlett (English, 1809–1854). *Ontario House, looking north from Maitland's Wharf at the foot of Church Street, showing Ontario House Hotel, Wellington Street East, in the background*, 1841. Steel engraving (Edward John Roberts) and watercolour on wove paper, 126.0 x 187.0 mm. Toronto Reference Library, (T.P.L.), J. Ross Robertson Collection (JRR 1840)

10. Photographer unknown. *Toronto City Hall (1844–1899), Front Street East, south side between Market and Jarvis Streets*, 1844

11. George Theodore Berthon (Canadian, 1806–1892). *William Henry Boulton*, 1846 Oil on canvas, 208.3 x 144.8 cm. Art Gallery of Ontario, Toronto, Goldwin Smith Collection, bequest of 1911 (GS111)

12. George Theodore Berthon (Canadian, 1806–1892). *Mrs. William Henry Boulton*, 1847. Oil on canvas, 59.1 x 44.5 cm Art Gallery of Ontario, Toronto, Goldwin Smith Collection, bequest of 1911 (GS49)

13. George Richmond (English, 1809–1896) *Sir John Beverley Robinson (1791–1863)*, c.1855. Oil on canvas, 76.7 x 63.5 cm On loan to the Art Gallery of Ontario, Toronto, property of John B. Robinson, Toronto (LN 36)

14. George Theodore Berthon (Canadian, 1806–1892). *The Honourable & Right Rev. John Strachan, D. D., Lord Bishop of Toronto*, 1843. Mezzotint on paper (William Warner), 31.4 x 24.8 cm. Art Gallery of Ontario, Toronto, gift of Arthur C. Neff, Toronto, 1934 (2163)

15. Photographer unknown. *The Grange Garden Party*, 1880

16. J. W. L. Forster (Canadian, 1850–1938) *Mrs. Goldwin Smith*, 1884. Oil on canvas, 63.5 x 76.2 cm. Art Gallery of Ontario, Toronto, Goldwin Smith Collection, bequest of 1911 (GS10)

17. Henri Perré (Canadian, 1828–1890) *The Grange*, c.1875. Watercolour and graphite on paper, 31.4 x 51.0 cm Art Gallery of Ontario, Toronto, Goldwin Smith Collection, bequest of 1911 (GS74)

18. Photographer unknown. *Goldwin Smith with a bowler hat and cane, seated at a table*, c.1880. Art Gallery of Ontario, Toronto, Edward P. Taylor Research Library and Archives (2412)

19. George Agnew Reid (Canadian, 1860–1947). *William Chin*, 1911. Oil on canvas, 102.9 x 76.2 cm. Art Gallery of Ontario, Toronto, gift of the artist to commemorate Chin's long association with The Grange, 1934 (2187)

20. Photographer unknown. *The Grange Library*, c.1900

21. J. Fraser Bryce (active in Toronto late 19th century–1909). *Harriette Smith and her dog Flossy*, c.1895. Art Gallery of Ontario, Toronto, Edward P. Taylor Research Library and Archives (2799)

Elaine Reichek (American)
As She Likes It, 2000
Embroidery on linen, in 5 parts, each displayed on a fireplace
screen stand
68.8 x 45.5 cm each, on a 180-cm stand
Courtesy of the artist and Nicole Klagsbrun Gallery, New York.

Elaine Reichek was born in Brooklyn, New York and
lives in New York City. Reichek is known for her use of
the age-old medium of embroidery to examine contem-
porary issues. In many works based on the sampler — a
traditional embroiderer's exercise incorporating narrative
images, patterns, and motifs framed by verbal homilies
and lessons — Reichek remakes existing images from high
and low art, replacing the aphorisms of the sampler with
quotations from a wide variety of sources throughout
history and literature. Reichek's works establish a cir-
cuitry of relationships and influences. The embroideries
in her 1999 *Project* exhibition at New York's Museum of
Modern Art, for example, referred to works by a number
of artists in the museum's collection, as well as to a range
of older images dating back to classical Greece. In 2000,
Reichek's work was celebrated in a major exhibition at
the Palais des Beaux Arts in Brussels, Belgium and at the
Tel Aviv Museum, Israel.

Christy Thompson (Canadian, born 1973)
camper, 2001
Cast resin, pigment, neon candelabra lights
Series of bottles, each 30 cm tall x 7.5 cm in diameter
Courtesy of the artist. The artist gratefully acknowledges the
support of Marianne Lovink, Gordon Hicks and Evan Penny.

Christy Thompson was born in 1973 in Toronto, where
she lives and works. She is a recent graduate of the
master's program in fine art at the University of Western
Ontario, London. Thompson's work caught the atten-
tion and imagination of Torontonians in 1998 with the
discovery of her "first-to-find-first-to-win" trophies,
inscribed "Good for you" and located in several public
places as part of the *off/site@ toronto* exhibition.
Thompson's work has been seen recently in several exhi-
bitions including the *Instant Coffee* miniature show in
Present Tense no. 17 at the Art Gallery of Ontario (2001)
and *Descriptions of What I Think I Know* at the Truck
Gallery, Calgary (2001).

Elizabeth LeMoine (Canadian, born 1958)
What Happened, 2000–2001
12 sculptures
Courtesy of the artist.
The artist wishes to thank Izak Westgate for his assistance.

12 elements:
1. *Record Album* (Glenn Gould), 2001. Paper, nylon, polyester, pigment, model cement, 7.5 x 5.5 x 0.3 cm
2. *Clown from Uncle Bobby,* 2001. Polythene, cotton and polyester thread, 9.5 x 5.5 x 1.5 cm
3. *Centennial Mugs,* 2001. Fimo, wood, paper, nail polish, 4.7 x 2.7 x 2.7 cm
4. *Dominion Exercise Book,* 2000. Paper, 9.7 x 7 x 0.1 cm
5. *Gym Suit,* 2001. Paper, cotton and polyester thread, elastic, plastic, 7.7 x 4.5 x 4.5 cm
6. *Dad as Mr. Peanut,* 2001. Paper, twine, nylon, wire, flocked paper, 17 x 4 x 4 cm
7. *Hockey Jersey (for F.M.),* 2001. Polythene, polyester and cotton thread, 20 x 12 x 2 cm
8. *Clown from the Santa Claus Parade,* 2001. Polythene, paper, polyester filament, 27 x 10 x 6 cm
9. *Grown-up Book,* 2001. Printed paper, graphite, ink, 9.3 x 7.3 x 2 cm
10. *Trade mark,* 2001. Polythene, polyester filament, 16 x 12 x 3 cm
11. *The 50,* 2001. Paper, foil, sparkles, 6 x 3.5 x 3 cm
12. *Prosthetic,* 2001. Polythene, silicone, foil, fimo, paper, 12 x 1.5 x 3.5 cm

Elizabeth LeMoine was born in 1958 in Toronto and lives in London, England. LeMoine makes finely crafted miniature objects with contemporary everyday materials. Often apprehended by chance like apparitions that catch the viewer off guard, LeMoine's objects use the radical transformation of the scale of familiar things to subtly focus and inform the spaces they occupy. LeMoine has participated in several projects engaging historical and public spaces beyond the museum or gallery context. She was artist-in-residence at Sadler's Wells Theatre, London (2000–2001). Her work has been exhibited widely in Canada and abroad and was included in *At the Threshold of the Visible: miniscule and small-scale art, 1964–1996* (1997) seen at several locations in the US and Canada.

Josiah McElheny (American, born 1966)
Four Mirrors, a Painting, and a Fiction by Jorge Luis Borges, 2001
A re-installation of the entrance hallway of The Grange
Courtesy of the artist, Donald Young Gallery, Chicago and Brent Sikkema Gallery, New York.
The artist wishes to thank Jessica Bradley, Jennifer Rieger, Jill Cuthbertson, Gillian MacKay and his assistants Nancy Callan and Jennifer Elek.

8 elements:
1–4. *Four Mirrors after a Fiction by Jorge Luis Borges,* 2001 Hand-blown sheet glass with interior patterning, silvering chemicals, mounting hardware. 41 x 56 x .65 cm each
5. Hand-held text of "The Draped Mirrors" by Jorge Luis Borges, DREAMTIGERS, 1964
6. George Theodore Berthon (Canadian, 1806–1892). *Mrs. William Henry Boulton,* 1847. Oil on canvas, 59.1 x 44.5 cm. Art Gallery of Ontario, Toronto, Goldwin Smith Collection, Bequest of 1911
7–8. Two AGO-style museum labels

Josiah McElheny was born in 1966, in Boston, Massachusetts and currently lives in Brooklyn, New York. McElheny works with the material nature of glass to explore the relationship between the medium's history in domestic craft and design and the traditions that shape the production of material culture. McElheny's work often refers to the conventions of museum display, including cases designed by the artist accompanied by his own narrative label texts. McElheny was the recipient of a Tiffany award in 1995. His work was included in the 2000 *Whitney Biennial* and the 2001 *Site Santa Fe* biennial. He has had several solo exhibitions including at the Henry Art Gallery in Seattle, Donald Young Gallery in Chicago and Brent Sikkema, New York.

ARTISTS' BIOGRAPHIES AND WORKS IN THE EXHIBITION

Rebecca Belmore (Canadian, born 1960)
Wild, 2001
Bedcover and canopy, fabric, fabric braiding, hair and fur
Dimensions variable
Courtesy of the artist and Pari Nadimi Gallery, Toronto. Thanks to
Florene Belmore and Osvaldo Yero for their generosity and
commitment.

Rebecca Belmore was born in 1960 in Upsala, Ontario.
She currently lives in Toronto and Vancouver. Her performance and installation art has attracted international
attention over the past decade in notable exhibitions such
as *Land, Spirit, Power* at the National Gallery of Canada
(1993), *Site Santa Fe* biennial exhibition (1995), *InSite '97*
(San Diego & Tijuana) and the *Sydney Biennial* (1998).
She has also had several solo exhibitions across Canada,
most recently at the Blackwood Gallery, Etobicoke, and
the Pari Nadimi Gallery, Toronto. Belmore has lectured
extensively on First Nations art. Her work in a variety of
media has addressed the legacies of cultural erasure and
restitution, highlighting the restrictive interpretation of
contemporary native culture confined in colonial stereotypes and promoted through today's tourist industry.

Robert Fones (Canadian, born 1949)
Childless, 2001
Backlit transparencies, photograph, mounted behind
clear plastic.
Approximate running dimensions: 2.1 x 12.3 metres.
Courtesy of the artist and Olga Korper Gallery, Toronto. The artist
gratefully acknowledges the assistance of: Natasha Greenblatt,
Emma Horrigan, Frances Hu, Peter MacCallum, Elke Town,
Vienna Home Bakery, Jones & Morris Photo Digital Imaging.
Photo of H. M. Schooner *Speedy* courtesy of Toronto Reference
Library (T.P.L.).

The photographic panorama was taken at the mouth of the Rouge
River, east of Toronto. The schooner *Speedy* sank in a storm on
October 8, 1804 off Presqu'isle Point in Lake Ontario. On board
was solicitor general of Upper Canada, Robert Gray, who owned
the land The Grange was eventually built on. His death allowed
the Boulton family to acquire the property. Since Harriette Dixon
Boulton and Goldwin Smith had no children, they left The Grange
to the Art Museum of Toronto. The ceramic doll was found during
excavation of the foundations under the rear kitchen at Vienna
Home Bakery on Queen Street, Toronto in July 2000. Emma and
Natasha both work at Vienna Home Bakery on Saturdays.

Born in London, Ontario in 1949, Robert Fones lives and
works in Toronto where he has exhibited regularly since
1972, most recently with Olga Korper Gallery. His work
is in the collection of the National Gallery of Canada,
the Art Gallery of Ontario and The London Regional Art
and Historical Museum. Robert Fones has worked in a
variety of media including sculpture, painting, woodblock printmaking and photography. In his work he has
consistently investigated the transition from manual to
industrial production, disclosed hidden processes of geological and cultural change, and exploited the innate
ambiguities of photographic and painted pictorial space.
This last theme is evident in *Head Paintings,* one of
many artist's books that Fones published with Coach
House Books. He has also written extensively for
Vanguard, C Magazine and *Parachute.*

Luis Jacob (Canadian, born 1971)
In All Directions, 2001
Light sculpture comprised of aluminum track, wires and LED bulbs
6 x 2 metres
Design and fabrication assistance by Leif Harmsen and Loris
Calzolari. Courtesy of the artist and Robert Birch Gallery, Toronto.

Luis Jacob was born in 1971 in Peru and lives in Toronto.
Jacob works in various media including painting and
sculpture, as well as more ephemeral forms of performance and public interventions. A common theme in his
work is the idea of home expressed through concepts of
building and dwelling. Through his work, Jacob has
addressed urban issues such as garbage disposal and
domestic architecture, engaging the symbolic, as well as
the real dimensions of public and private space. Jacob has
participated in many collective artistic initiatives and
community projects. His work has been seen in several
exhibitions, most recently in a solo exhibition at the
Robert Birch Gallery, Toronto.